THE BEGINNER'S GUIDE TO
Oil Painting

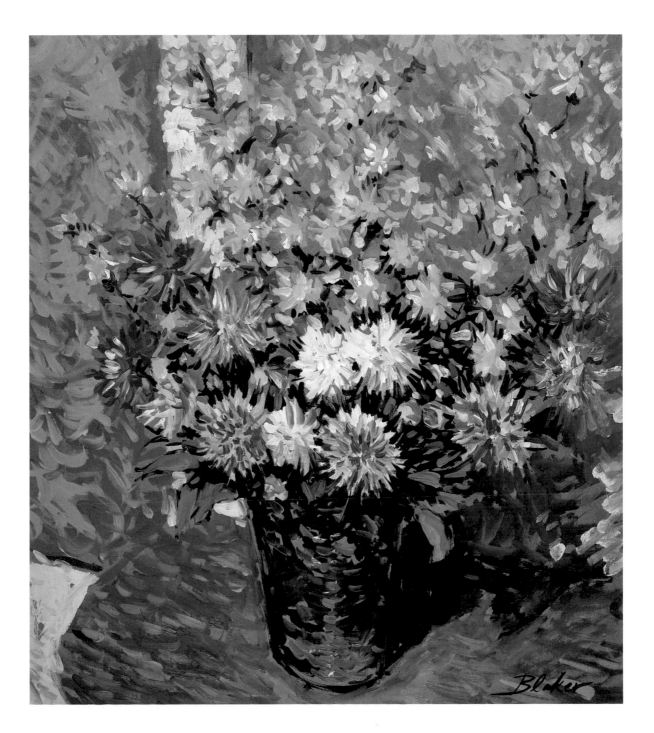

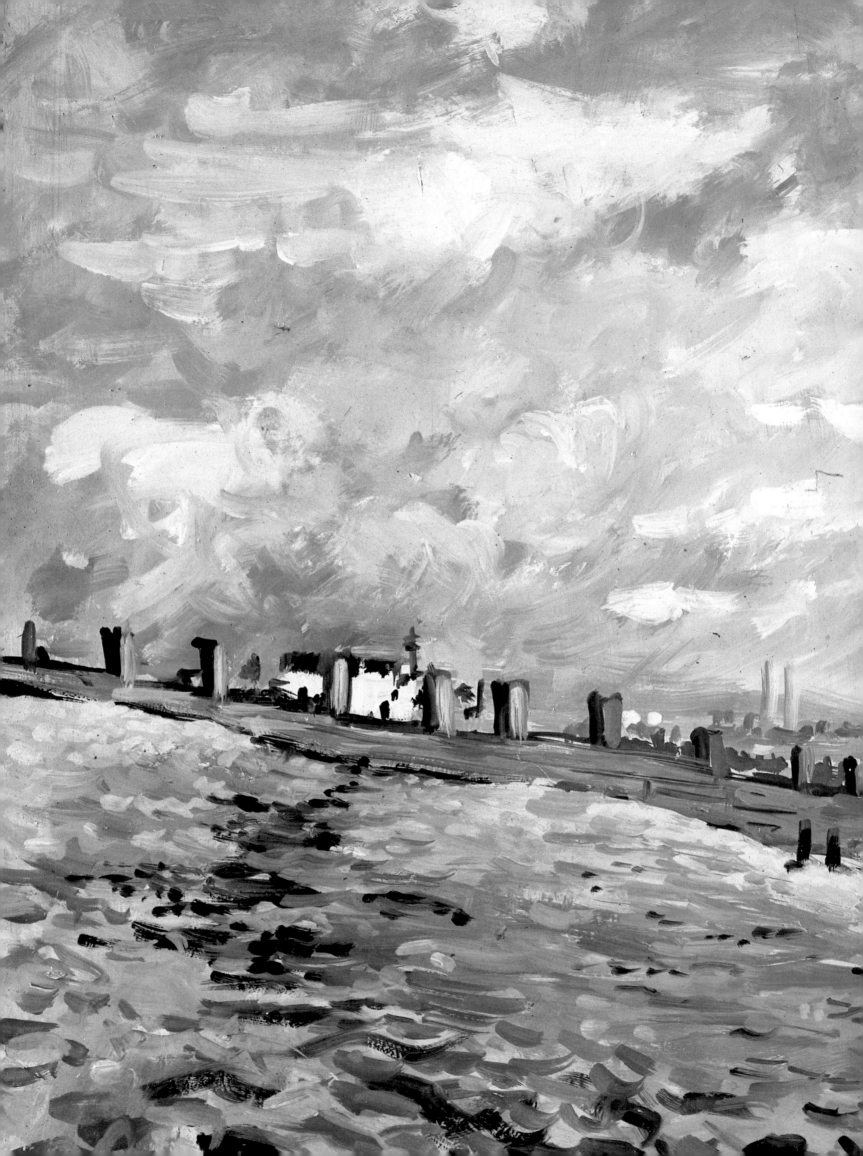

THE BEGINNER'S GUIDE TO
Oil Painting

Michael Blaker

CHARTWELL
BOOKS, INC.

Blaker

Published by
CHARTWELL BOOKS, INC.
A Division of BOOK SALES, INC.
110 Enterprise Avenue
Secaucus, New Jersey 07094

Produced by
Brompton Books Corp.
15 Sherwood Place
Greenwich, CT 06830

ISBN 0-7858-0017-4

Printed in Hong Kong

The right of Michael Blaker to be identified
as the author has been asserted by the
same in accordance with the Copyright,
Designs and Patents Act 1988.

All artwork is by the author unless
otherwise stated.

PAGE 1
Michael Blaker
*Chrysanthemums and
Delphiniums in a Vase*
Oil on board, 28×24 inches
(71.7×61.4cm)
PAGES 2-3
Michael Blaker
*The Old Power Station and
Hove from Lancing Beach*
Oil on board, 24×16 inches,
(61.4×41cm)
RIGHT
Michael Blaker
Jenny Nude
Oil on board, 36×60 inches
(92.2×153.6cm)

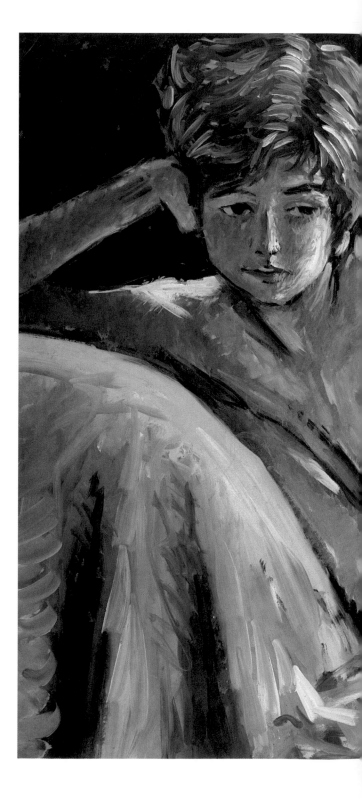

Contents

Introduction 6

1. Materials 10

2. Preparation 20

3. A First Landscape 26

4. Flowers, Fish and Animals 32

5. Sea and Weather 48

6. Compositions 56

7. Portraits 60

Index 80

Acknowledgments 80

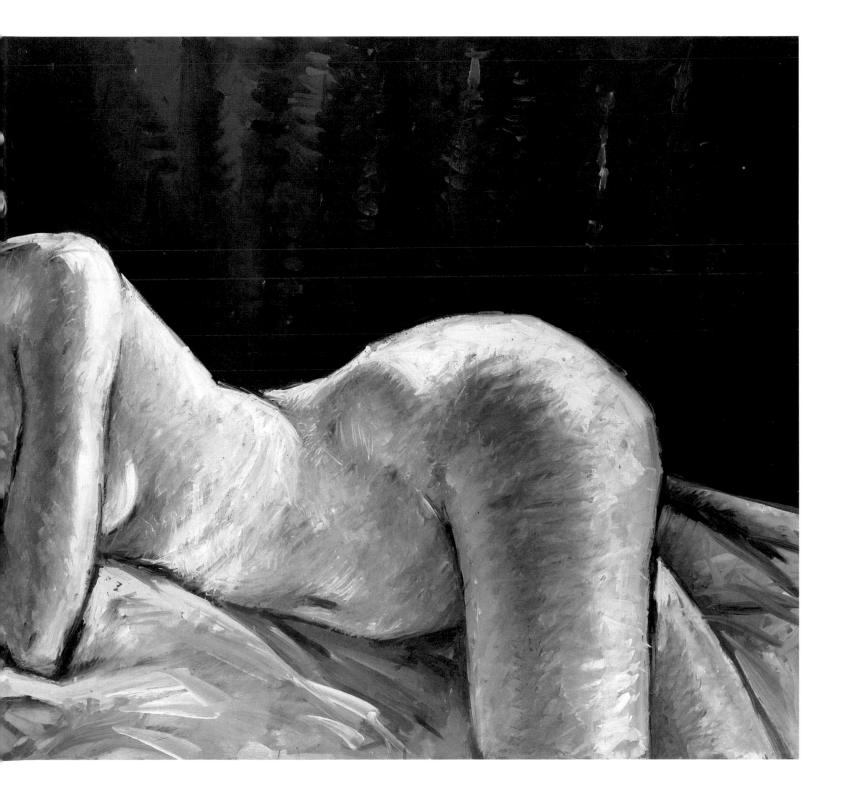

Introduction

To the uninitiated, the practice of oil painting may well seem to be one entirely shrouded in mysteries. It should always be remembered, however, that there are no secrets in oil painting, only steady procedure. This must, however, be learnt; and the only way to do so is by working through the various methods and approaches to this diverting craft. I say craft, because that is the basis of your learning. The art must come from yourself – from your ideas, your inspirations, your thoughts concerning pictures and places that you have seen.

If this sounds a problem I would remind you that ideas breed more ideas, and that the examination of pictures in galleries, and I mean good pictures in major collections such as the National Gallery of Art in Washington, the National Gallery in London, the Louvre and the Musée d'Orsay in Paris, will give you many thoughts and in-

spirations for paintings that you wish to accomplish yourself. It is particularly advantageous to visit such museums while you are actively engaged in painting regularly. You will find that the great artists are your brothers as well as your mentors: they will give you help and advice. Stop before a painting that takes your fancy and read it; take your time, it will tell you many things. You will find all your problems, all that has been worrying you, there before you: not necessarily solved in the same way but managed, perhaps even circumvented, in ways that you had not thought of. So always go to the masters! Do not be too proud to do so. Those who are the best painters regularly go to the font to refresh themselves. And the interesting thing is that, however good you get, you will find the great ones – Manet, Degas, Ingres, Corot – are always ahead of you. As they should be; otherwise how

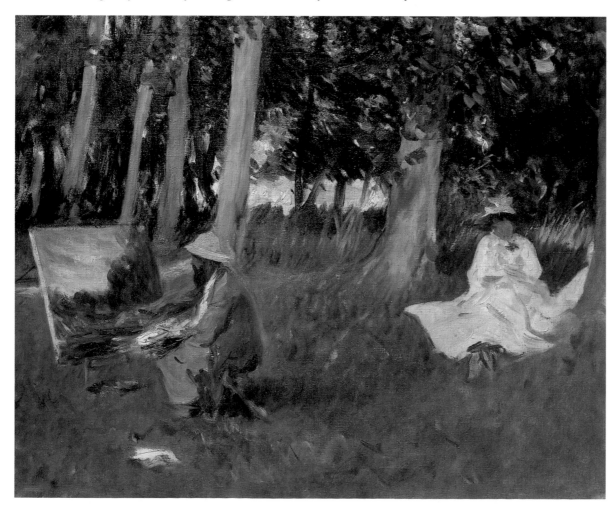

could you continue to learn from them all your life?

To begin with, painters were restricted to pigments mixed with water or glue on wet or dry plaster, then progressing to egg tempera, in which the powdered pigments were mixed in various ways with egg to bind them. This was laborious, and the technique invented by the fifteenth-century Flemish painters in the north of mixing the oil from crushed linseed with the pigments resulted in an easily flowing medium that did not dry at once (as with earlier methods). When it did dry it possessed a high finish that gave a depth and reality to the paintings that was not previously possible. The degree of finish could be altered by mixing more turpentine with the oil to give a flatter effect if desired, or by adding various varnishes, formed by dissolving resin in turpentine, to emphasize the gloss. Other oils, such as poppy, were also used; and if you consult any of the extensive books on the subject from the fourteenth century to the present, you will find endless recipes and formulae for the various methods of painting in oils.

The invention was carried from Flanders to Italy by way of Antonello da Messina, or

FAR LEFT
John Singer Sargent (1856-1925)
Claude Monet Painting at the Edge of a Wood
Oil on canvas, 21¼×25½ inches (54.4×65.3cm)
This has all the feel of a painting made from life; the artist is unworried and thinking only of the scene before him.

BELOW
Alfred Sisley (1839-99)
The Canal St Martin, Paris
Oil on Canvas
A wonderful example of golden summer light.

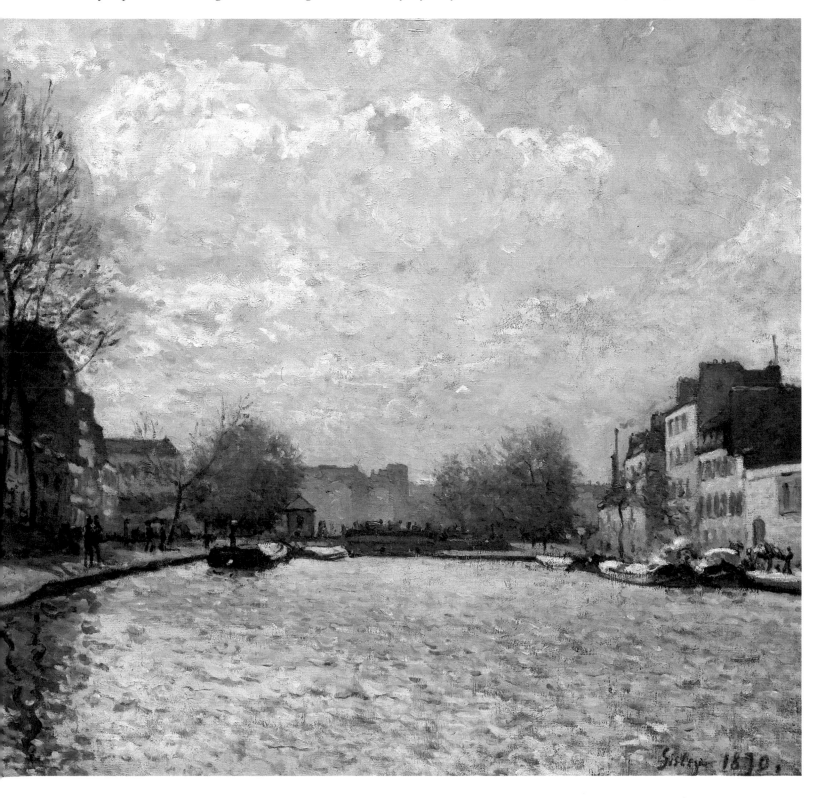

so it is said, and the great muralists such as Raphael, Perugino and other fifteenth- and sixteenth-century artists took to it at once. In Holland by the seventeenth century, Rembrandt and the others were using the style with increasing impasto, that is laying on great thick and chunky areas for particular emphasis, and going over this when dry with thinner colors. This method, called glazing, was one of the other bonuses of oil painting from the beginning, in that surfaces could be built up by overlaying thick and thin layers to give increasing depth and power. Eighteenth-century portrait painters

such as Reynolds followed the style of Titian by painting the subject initially in black and white, and then adding all the colors as overlaying transparent tints.

The nineteenth-century academic painters, Ingres in particular, took this style to an increasingly fine level of almost enamel-like quality. The painters of the Barbizon School, who lived in a village and painted tree-filled landscapes, gradually adopted an even freer style. They paved the way for the Impressionists, who developed the *premier coup* manner of painting direct from nature and not re-touching or overlaying the surface further, so that the spirit of outdoors remained and gave a permanent vitality to the painting. As these pictures are still today the most vibrant in the galleries, the Impressionists seem to have got the most out of oil painting, perhaps, in the way in which they developed its use.

The Impressionists, being young men, also liked the contemporary vista of trains, iron bridges, the newly rebuilt Paris and other scenes that look picturesque to us today but seemed perhaps quite hideous to their contemporaries when first exhibited, and may have been one cause of the apparent shockingness of these painters! The Post-Impressionists, above all Gauguin and Van Gogh, took this shock factor one stage further, laying the basis for much of twentieth-century painting.

FAR LEFT
Seated Nude in Life Group Session
Oil on board, 24×20 inches (61.4×51.2cm)
In this picture, painted on a gray-white ground, I have carried the summary brushwork into a fairly solid modeling with highlights. The background figure adds life and movement to the image, although the pose of the model is a good one in itself, vibrant and lively.

LEFT
Man with a Cigarette
Oil on board, 48×24 inches (122.9×61.4cm)
The smoker is a favorite subject with artists – see, for instance, Manet's *Le Bon Bock* on page 69. The liveliness of the curling gray spiral has the attraction of the evanescent, but for best results you must put it in directly over wet paint, so that it merges convincingly into the atmosphere. This was painted partly as an exercise in working by direct slabs of tone, light and shadow, without any particularly linear treatment.

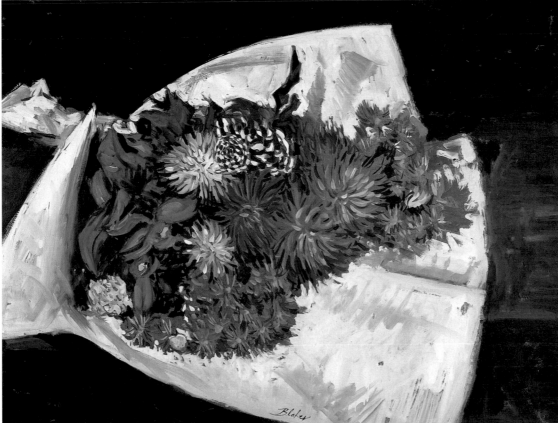

LEFT
Dahlias on a Table
Oil on board, 24×16 inches (61.4×41cm)
One way to paint flowers is as a bouquet, with paper round them. The flowers themselves are painted quite thinly; the air of richness comes from the emphatic contrast with the white areas. You could paint them with a palette knife if you wish, or emphasize different petals – it is up to you.

1. Materials

Colors

Leaving the more grandiose lines of thought discussed so far, let us proceed to the actual techniques, prodedures and all the varying and interesting spheres of this occupation that you have before you. Firstly, it is not necessary to purchase at once all the myriad hues of the rainbow as regards your selection of color tubes. Color is a question of what is placed next to it. The great Dutch painters of the seventeenth century, such as Frans Hals (c.1581-1666), worked with a simple palette of vermilion (which is an orange-red; yellow ocher (a simple earth color with no particular vibrancy, so it blends well); black (which when mixed with white for the sky will even give the impression of blue because you *expect* it to); and, of course, white. To include a vibrant bright yellow in this Dutch range would mean that you would have to tone it down all the time. The Impressionists, on the other hand, made use of the new brighter chemical colors that were being developed in the nineteenth century, in order to give the added brightness that working outdoors in bright sunshine seemed to demand; and indeed, I would advise their use – but not too many! You need not confuse yourself with a million colors, as I say.

The colors I use when working outdoors in the Impressionist tradition are a selected list of artist's oil colors. Never use Student's Colors; they have no zip, no life, and you will muddy your work for the sake of a spurious economy. It is important always to use the best paints and brushes, or you are not giving yourself a chance. There are various arguments that some people may put against this, such as that two tins of shoeshine in a master's hands may create a timeless wonder. And there is the story of Sir Joshua Reynolds in the kitchen producing a masterly design on a cleanly scrubbed table with his thumb dipped in a bottle of ink (we are not told of the cook's reaction). But such tricks of virtuosity are not what painting is all about, but are merely the sophistries of genius. We are here to find out how to paint,

and it is done by steady and thoughtful application, and ideally by sticking to the rules, if you want to succeed.

Continuing with the colors that I would recommend for your outfit – and the idea is to start painting right away – we need a yellow; Winsor Yellow is an excellent choice. Ultramarine for blue will give you a wide range of tints, down to an intense depth, and goes a long way. Blue-black is better than Ivory Black as it does not dry with the deadness that Ivory Black is prone to, and Raw Umber (another earth color) you will find extremely useful. Yellow Ocher will also give you fine muted greens when mixed with blue-black and a little blue, though keep this last to a small amount. Never buy

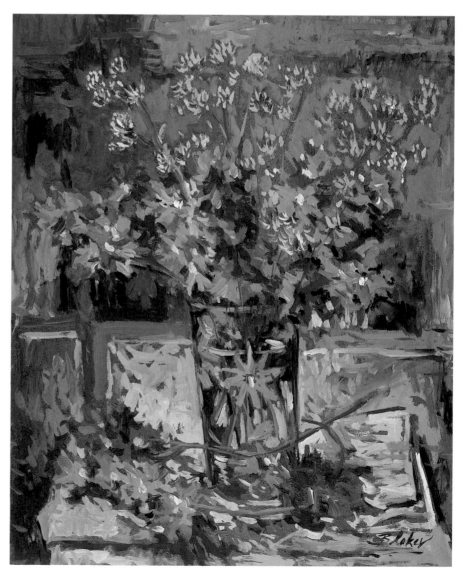

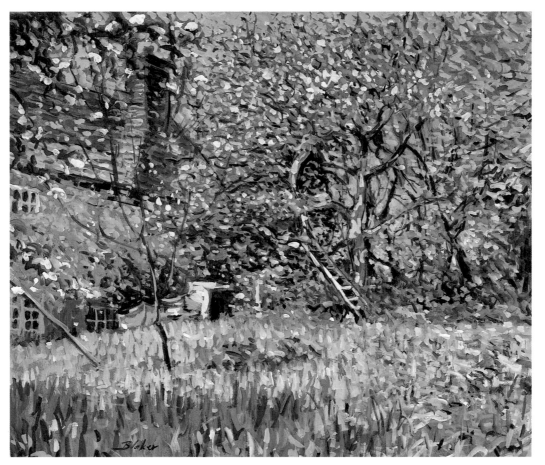

The Orchard at Woodlands, Wiltshire
Oil on board, 20×24 inches (51×61.5cm)
Spring blossom is a gift to the artist, making a glittering contrast to the fresh green spring leaves, but you have only a few weeks, or days, in which to take advantage of it. Slight breezes will make the blossoms fly about, and you can whizz these in as you notice them; they give the movement and freshness that you want. Here the red of old roofs and the ancient ladder also contribute to the atmosphere of the old farm.

Alfred Sisley (1839-99)
Small Meadows in Spring
Oil on canvas, 21⅜×28¾ inches (55×73.6cm)
A beautiful evocation of a spring day, glowing with light, and including golden touches where the fresh sunlight is striking. All is direct and unhurried.

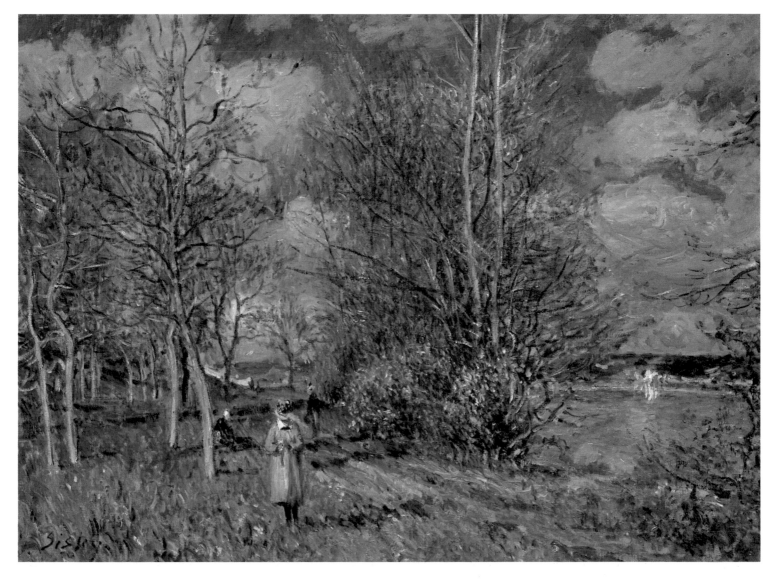

green in a tube. Bad paintings are usually bad because of the over-use of green, which kills all aesthetic qualities in a painting. The green of nature has a lot of red in it. Remember this when mixing your colors on the palette as you work.

There are two ways of mixing colors. It is better to do this with your brush by a kind of instinct (which will develop, I can assure you, as you go on) matching them to the area in front of you. It may be a tree, but you will think of it primarily as a shape and color. Alternatively you may wish to use your palette knife (a kind of small spatula) to mix a larger amount of the desired tint from the pigments spread out on the palette.

Regarding the palette, you can buy an oval-shaped wooden article to hang on the thumb of the left hand, and no doubt this can be convenient. For myself, I would choose a hinged-lid metal tin, available for a small sum in any hardware store. You can place this either on a seat beside you – per-

haps a folding chair - or on your lap on a sheet of newspaper. The advantage – apart from keeping the colors from drying up – is that you have only to close the lid and the tin can be at once put back in your bag if you wish suddenly to accept the offer of a drink, or escape the field speedily on the approach of a bull, or even of a herd of cows, who find great interest in outdoor painters and even eat their tubes of paint. These points are not made merely to be amusing. It is useful at times to be able to pack up easily. The tide may be coming in; and there is always the threat of sudden rain.

For your medium, which is the liquid with which to thin the colors, I recommend a bottle of mineral or white spirit from the do-it-yourself store. This can be used both to thin the colors and also to clean your brushes. You may prefer for the thinning to use genuine turpentine or artist's turpentine, which are a little thicker in consistency. Try both. When out painting take with you

ABOVE
View of the Downs from behind the Church at Berwick, Sussex
Oil on board, 18×24 inches (46×61.5cm)
A tranquil, still midday, with a bit of a heat haze that pulls the tones together. Always accept what the day brings; never impose some other atmosphere or mood on the subject when working from life. The intense sunlight catching the saplings is a very useful foil to the otherwise close tones, and the passing riders – put in quickly as they fortuitously appeared – help to take the eye into the picture. Always take advantage of such pieces of life that arrive as if ordered to assist your composition.

small glass jars with screw tops to contain the liquids for both purposes (unless you have bought very small quantities in small bottles) and write on them with a marker pen which is which. You should also take with you a richer medium, a brand-name artist's painting medium, or you can make one up yourself, with the traditional formula of half linseed oil and half genuine turpentine plus a drop or two of a varnish, all available in an arts material store.

The varnish is also useful in hastening the paint's drying, according to how much you add. If you add a great deal you will have a surface that tends to a gloss or lacquer-like effect. You may want this, but it runs the risk of cracking. Apart from these considerations, I am primarily at this point kitting you out for a day spent painting in the country or immortalizing a bunch of flowers from the garden at home, and assuming that you want to get down to it as soon as possible.

Two other colors are necessary, but you will not need to squeeze out much on the palette, as they are expensive and are to be used only when mixed with white. These are Alizarin Crimson, used for painting roses, as you cannot get that tint otherwise, and Purple Lake, useful for bluebells. The subject of bluebells has come in for some

cynical criticism by art sophists over the years, but just you try painting a bluebell wood and getting that odd misty blue, like a hovering haze . . . You should also try a tube of Indian Red, another earth color. You will notice I have not yet mentioned white. A tube of Flake White is useful, but you will need more than this. Equip yourself with a

tin of ordinary commercial white decorator's undercoat paint, stir it up well (first pour off some of the excess liquid and add more later if what remains is too thick) and put an amount in yet another small glass jar.

You will also need several small tins with lids to use as dippers. Do not bother with buying the official ones that clip on to the traditional palette (unless you want to, of course). Pour your medium (turpentine, mineral/white spirit, artist's medium or linseed and turpentine) into one of these, put spirit for cleaning brushes into another, and some of the white undercoat into a third. With the lids kept handy, these will again make it easy for you to stop painting and pack up in a moment if so required. The reason for the white undercoat is that you will use it to mix with the other colors to make your correct tints. You will also find it useful in getting down your statements quickly, so that they flow in time with your

thoughts and with the rhythm that will develop as you work. You can use the thicker Flake White tube color for this if you wish, but it is most useful when you require some kind of extra accent, such as light on water, when it can be applied swiftly with a dash of the palette knife. Admittedly, there is of course some expertise and experience needed for this, but now is the time to begin experimenting!

Brushes

Get yourself some sable brushes and do not stint on the expense. They will last quite a long time provided you cherish them. By this I mean always wash them first with mineral/white spirit, then soap and water, when you stop painting and before you do anything else. Never leave them by the palette while you go off and talk to an unexpected visitor for half the morning. Always

BELOW
The Old Tollbridge, Shoreham
Oil on board, 20×24 inches (51×61.5cm)
This is a fine picturesque subject, possibly the only bridge remaining in the style of Whistler's favorite one at Battersea, and most interesting to analyze as you paint or draw it. The subject is not only anecdotal or romantic, however, but a good one for the study of glittering sunlight on slightly green wood piles with weed at their base.

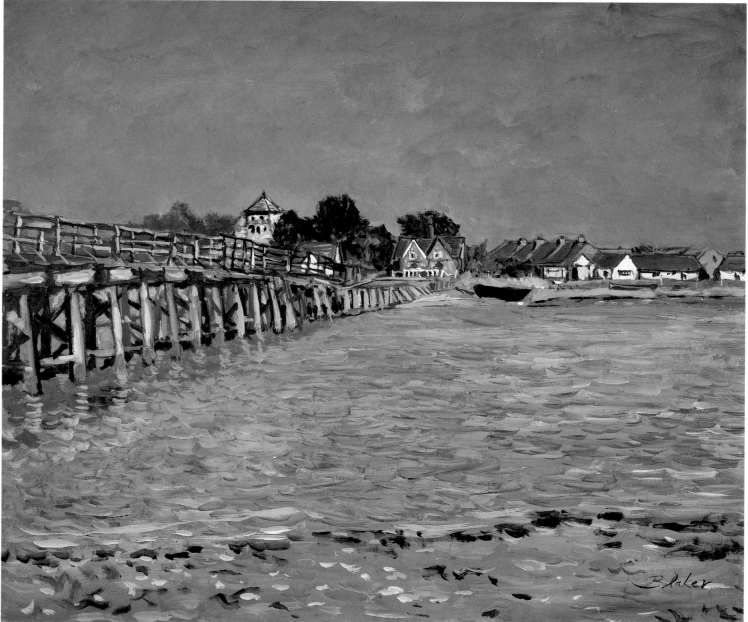

remember *your brushes come first*; they are more important than the painting. Brushes come in a variety of sizes, and ideally you should get yourself three or so of each, if you can stand it, from size 2 up to 12, say in even numbers. You can buy some square- and round-topped flat hog-bristle brushes if you like, though these work best when well worn in, unlike the sable, which needs its point kept. You will also need to buy two or three small ordinary household paint brushes. They can come in useful. A couple of rolls of soft toilet paper are also useful, to clean your brushes on and to keep your hands clean, as oils have a strange habit of spreading on to self and clothes.

Additional Materials

Regarding clothes, wear old ones when painting, that you do not mind sitting on the ground in. Take a cushion on a painting expedition, together with your folding seats (one for yourself, one for your palette) and buy a small lightweight sketching easel. I would suggest sitting to paint rather than standing, as exhaustion can affect the quality of work and make you hasten to finish; and it is inconvenient to hold everything as you paint. Sitting on the ground or on a seat means you have comfort and freedom, and this is everything. Never suffer to paint. Artists do not paint better pictures while starving in garrets, nor do poets write better poems in prison, whatever Picasso may have said – of course, you can get ideas from anything, it is true. It was in fact Picasso who developed the technique of using white commercial decorator's under-

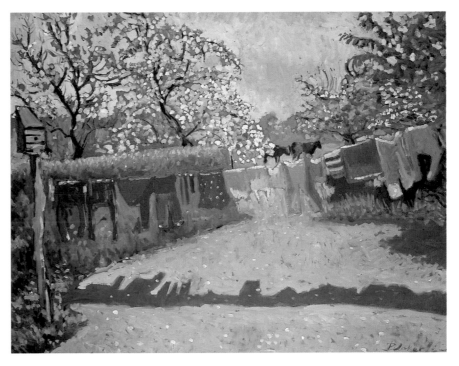

ABOVE
Washing on a Line
Oil on board, 48×60 inches (123×153.5cm)
The inspiration here is the sunshine pouring through the wet washing, giving the effect of stained glass windows in its intensity. The spring blossom also helps to convey the fresh, bright newness of the year, also perhaps symbolized by the clean washing. This is a large painting to work at on the spot, but a figure subject, being fairly close up, is less of a problem than a giant panoramic view. The cows appeared at the right moment to fit in to the composition; always take advantage of such a bonus.

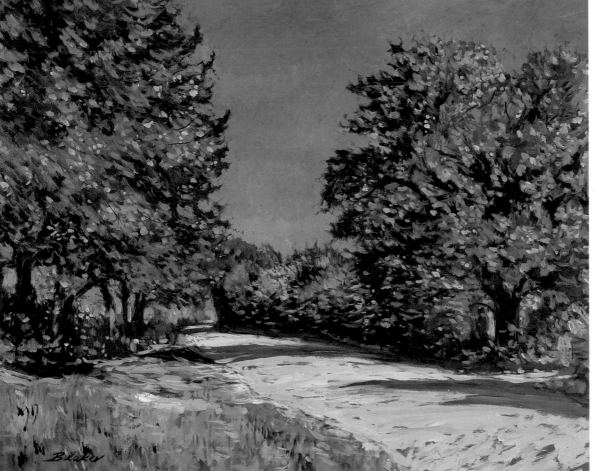

LEFT
A Country Lane, October Afternoon
Oil on board, 20×24 inches (51×61.5cm)
Here is another tranquil scene, still with the warmth of summer, but it will become autumnally cool in a few hours. The sunlight is picking up the increasingly coppery leaves. You can use a bright orange for these effects, and later on in the season there is the pleasure of painting whole trees with this brilliant sheen.

coat with oils, when he came upon the French commercial paint Ripolin and found it gave him the opportunity to paint speedily and cover large areas effectively before his inspiration cooled.

The old masters who painted giant portraits and decorations naturally mixed up their colors in buckets (or directed their assistants to do so) from white lead, varnish, oil, turpentine and dry colors, to whatever degrees of viscosity the area demanded. Tube colors were invented primarily for the convenience of painting outdoors, and then for the sake of convenience anyway. You may still make your own oils by buying powder pigments (by weight, as required) from a specialist artist's materials store, where you should also be able to buy most of the items I have been describing. Using a palette knife for small amounts, with some powdered white, and with oil and varnish, you can make up your colors and even buy empty tubes to put them in. Nevertheless this takes time and trouble, and if you can afford the, admittedly quite expensive, tube colors – though many of them will last a very fair time – it may be easier to do so. You do not necessarily need a wide range of colors. In fact it can be beneficial to start with a limited palette.

The Support

The support is what you are going to paint your picture on, having got everything else ready. Canvas is of course traditional, but to buy ready-made-up canvas on stretchers is extremely expensive, and to my mind seldom very satisfactory. To begin with, unless you buy the most expensive, the cotton and other thin substitutes are far too fragile, easily damaged or punched in, and are not tough enough anyway, particularly, for outdoor work. Also the vast expense of a canvas and its pristine whiteness before you tends to inhibit both hand and inspiration, and you tend to save it up forever for some *really* important work. Which is not the way to proceed as a painter. You will get good by *painting*: so you need plenty of supports handy.

In an early Victorian manual on the painting of outdoor oils from nature we come upon the following advice: 'You will need some small wood panels, of about the dimensions of cigarbox lids. The local village carpenter will be pleased to saw you a selection of thin boards of this sort from seasoned oak for a few pence.' Such riches, arising from the poverty of village life, are no longer with the world today; perhaps happily, from

Catriona and Hero in the Garden at Rochester
Oil on board, 20×24 inches (51×61.5cm)
This picture has the vibrant animation of a garden in sunlight. Flick your brush about when painting this effect, to follow the movement of the leaves and petals in the slight breeze of the sunny day. The little white dog makes a useful note.

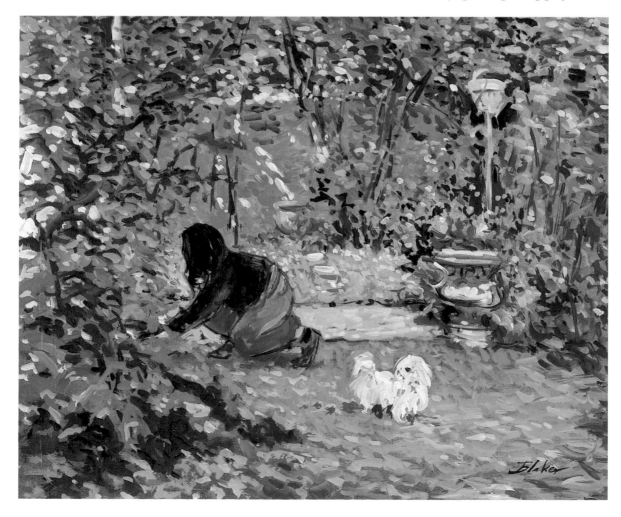

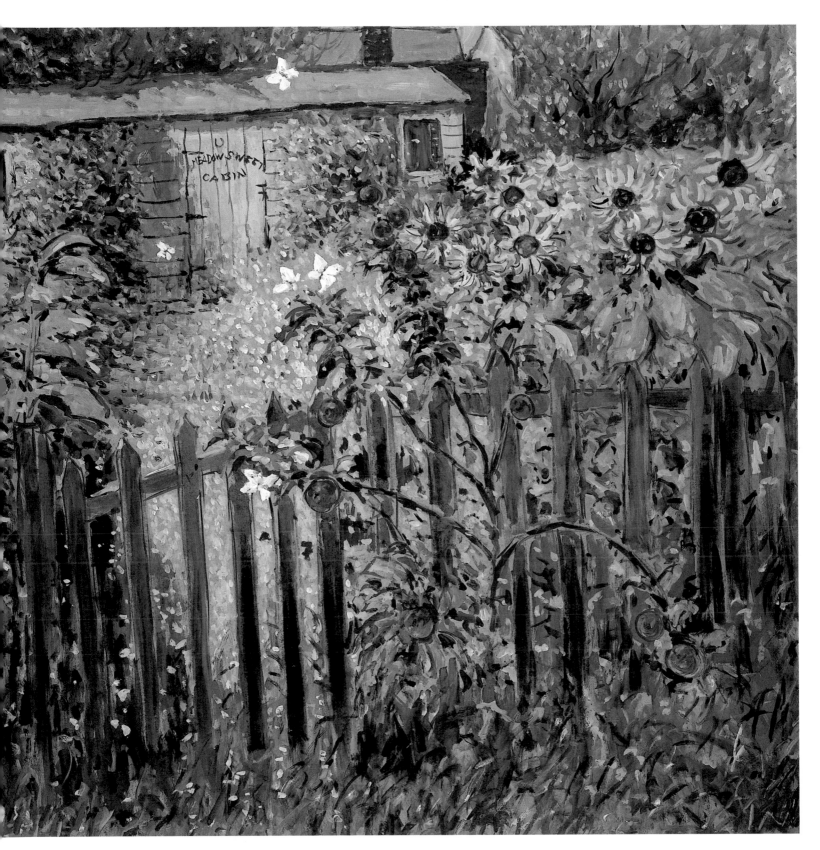

ABOVE
Meadowsweet Cabin with Sunflowers
Oil on board, 48×60 inches (123×153.5cm)
These flowers are always fun to paint, as they are so individual. Remember to step up the yellow, as they glow like the sun and seem to absorb more light than most blooms. The white butterflies were put in as they flew by, to give the atmosphere a sense of warmth and summer.

the point of view of the carpenter. We have other advantages, however, such as hardboard, which is very cheap. This can be sawn up for you, to fit the proportions of any frames that you may have around, or you can buy it by the sheet and saw it up yourself as required. Being slightly absorbent, this requires practice to use, but it is portable. You can construct a box to accommodate several panels so that they may be taken home without covering everyone near, including yourself, with reminiscences in paint of the natural scene, and also spoiling your work. Such cigar-box-sized panels painted from nature on the spot were traditionally known as *pochades*; academic painters in both France and England would, in the nineteenth century and quite well into the twentieth, take their students off in the summer in order to stay at a local inn and range the countryside making such sketches in oil. Some inns, such as the *Swan* at Fittle-

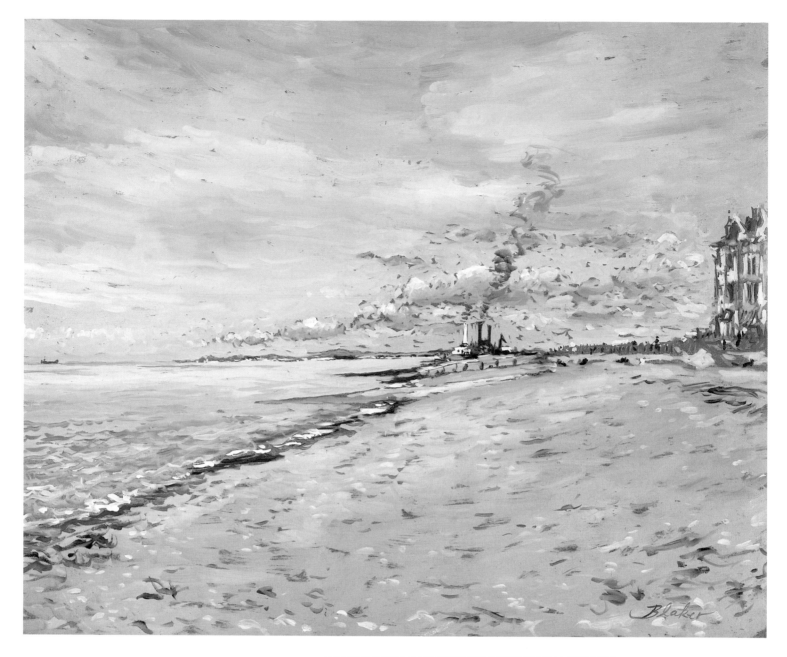

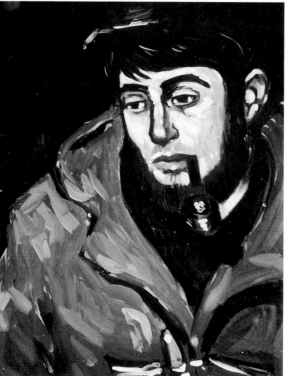

worth in Sussex, England, still have rooms paneled with *pochades* left behind or donated by students.

If you wish, you may paint your hardboard panels with a ground of white undercoat (or even other colored undercoats, which are also useful as an adjunct to your palette but on the whole lack any vibrancy). You should then tone it down by rubbing it over with a cloth soaked in a little Raw Umber oil paint diluted with paint thinner. Do remember, incidentally, that this is inflammable and keep the bottle top on.

It is always advisable to tint any white support, so that every touch you put on it, even the first, is harmoniously in tone with the ground coloring and does not stand out as too dark in contrast, as it does upon a white ground. Both the Pre-Raphaelites and the Impressionists used white grounds, with the aim of the white gradually coming through over the years, as paint has the

ABOVE
The Old Power Station from the Beach
Oil on board, 20×24 inches
(51×61.5cm)

ABOVE RIGHT
The Palace Pier, Brighton
Oil on board, 20×24 inches
(51×61.5cm)

LEFT
Man with a Pipe
Oil on board, 20×16 inches
(51×41cm)

RIGHT
Tree Study, Morning
Oil on board, 20×24 inches
(51×61.5cm)

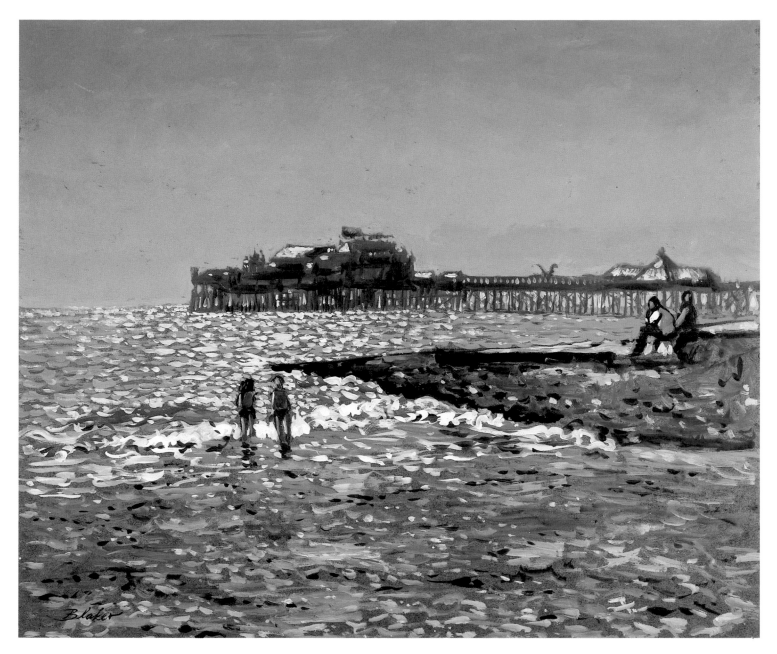

reputation (somewhat over-exaggerated) of thinning as the centuries go by, and thus giving extra illumination. It is a theory that is not too significant, as many earlier red- and brown-grounded paintings seem bright enough once the surface has been cleaned, and possibly brightness is not as important as harmony, after all. Whistler painted on a black ground, and while this may be said to be overdoing it somewhat and taking the opposite stance to its limits, we still enjoy his work very well. Of the three landscape studies shown here, the *Tree Study* (right) is painted direct on to the unprimed hardboard. The aim here is to catch the intense sunlight on the treetrunk. I have ignored the local color of the bark and simply put in what I saw – bright yellow/white hitting the surface. The sea study above catches the glittering effect of the sea in late afternoon, while *The Old Power Station* (above left) shows a morning scene.

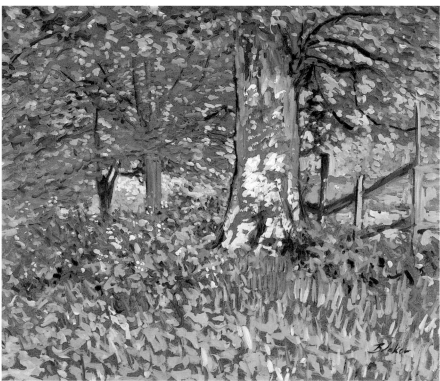

2. Preparation

Stretching the Canvas

Canvas, of course, is very pleasant to work on, and many painters will tell you how the slight feel of 'give' on a stretched canvas adds to the pleasure of painting. I think the accompanying drawing will give a better idea of stretching a canvas than a description in words. The principal point to bear in mind is to buy the best linen flax canvas of a medium weight, not the thinnest, as this will stretch well. White cotton duck canvas is also very satisfactory. After tacking it on the stretcher, which you can either buy from the arts material store or make yourself, it will be necessary to make up some rabbit-skin 'size' as it is called – this is merely a thin glue – and paint it on the canvas now tacked

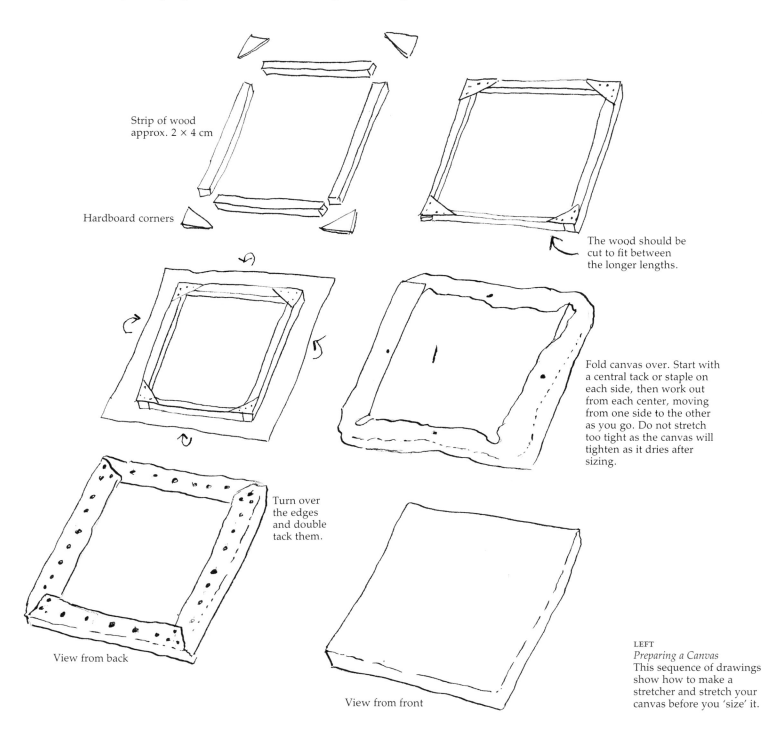

Strip of wood approx. 2 × 4 cm

Hardboard corners

The wood should be cut to fit between the longer lengths.

Fold canvas over. Start with a central tack or staple on each side, then work out from each center, moving from one side to the other as you go. Do not stretch too tight as the canvas will tighten as it dries after sizing.

Turn over the edges and double tack them.

View from back

View from front

LEFT
Preparing a Canvas
This sequence of drawings show how to make a stretcher and stretch your canvas before you 'size' it.

to the stretcher. This must not be stretched too tight to begin with, as the size contracts when drying. Experience will teach you how to do this, and the size may be purchased from an arts material store with full directions as to preparation. It should be melted in a container placed in a saucepan of water, with one cup of size to 13 of water, and heated and stirred but not allowed to boil, just like mulling wine.

Another idea is to cut a piece of canvas and size it on to a cut sheet of hardboard. You need to size the board, place the canvas on it and size the canvas, all in one operation. It is probably better at first to keep to 20×24 inches (50×60cm) as the maximum measurement for your supports, with some smaller ones, cut down to 8×10 inches, for easier conveyance of small landscape panels. It is difficult to paint from life on canvas larger than 20×24 inches, as one cannot look round the larger canvases easily to see the subject. If you have no canvas, you can use pieces of old cotton sheeting, and size that to hardboard. It is rather difficult smoothing out the bubbles; you should do it with a piece of cloth. Only cotton will be of use, not man-made material. If it dries with a bubble, work over this with more hot size.

Undercoat and Toning

When dry, all these supports will need two coats of white decorator's undercoat, followed by a toning with rubbed-over Raw Umber and mineral/white spirit – not too

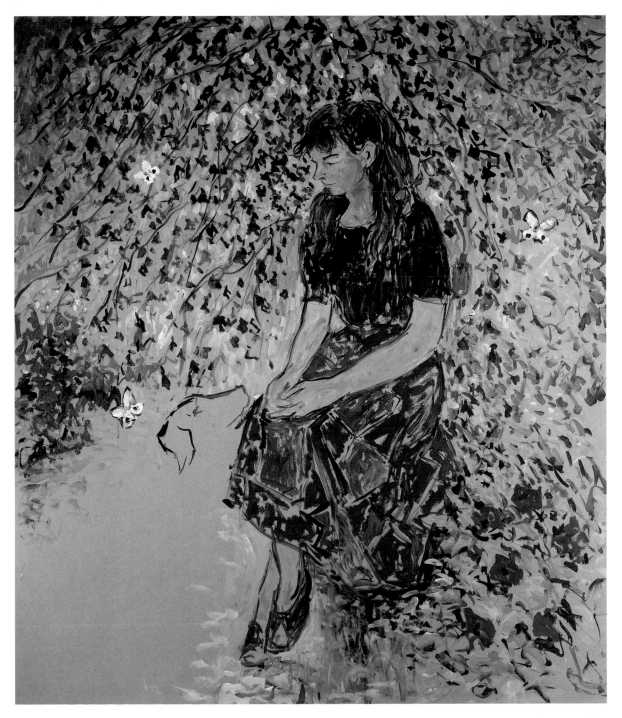

LEFT
Catriona under a Tree
Oil on board, 60×48 inches (153.6×122.9cm)
This unfinished study was made as one of a series of the same tree and sitter, and show how the image begins to emerge as the paint is laid on the ground. The tree, a weeping birch, moves slightly and shimmers in the breeze, so that the leaves take up varying sparkles of green and gold.

much spirit. Leave a day between coats and toning. You can buy a ground preparation to paint on the canvas, and you can also make up grounds with plaster, size and white lead, etc. As this can become somewhat abstruse, not to say highly technical, it can be left to your own experimentation. The early Italians would slake their plaster for six months in a bucket of water, pouring off the water at intervals and replacing it, in order to remove all impurities, acid lime qualities and so on, then mix it with rabbit-skin glue and spread it upon canvas or a braced wood panel, eventually smoothing it down with ivory polishers. At present, as we wish to get on with our painting, we had best avoid all these complications and use a hardboard panel just as it is, or prepare a panel or a sized canvas with undercoat; and we are now ready to commence.

Incidentally, do not buy white prepared textured artist's board. The imitation canvas effect is not professional, and the surface is slithery and off-putting.

Preliminary Techniques

There are perhaps just one or two points to mention before you start to paint. The paint technique known as scumbling is the over-painting, with a fairly strong bristle brush, usually of thicker paint over paint already dry; and one must stress that this must be dry. Interesting effects and variations can be achieved in this manner, and you can in a sense go on forever. This is obviously not a technique that lends itself too well to painting from life, with the subject before you, all on one day; but it can produce a valuable emphasis on certain passages in studio compositions.

Some painters will go on for years gradu-

BELOW
The Downs and the Weald
Oil on board, 20×24 inches (51×61.5cm)
This freely treated picture is intended to give a generalized evocation of the atmosphere, rather than being a portrait of the landscape, and the movement of the clouds is the main focus. You should throw your clouds in quickly, as quickly as they themselves are moving, and resist the urge to retouch them later, or you will lose that sense of life which is the main purpose of the exercise.

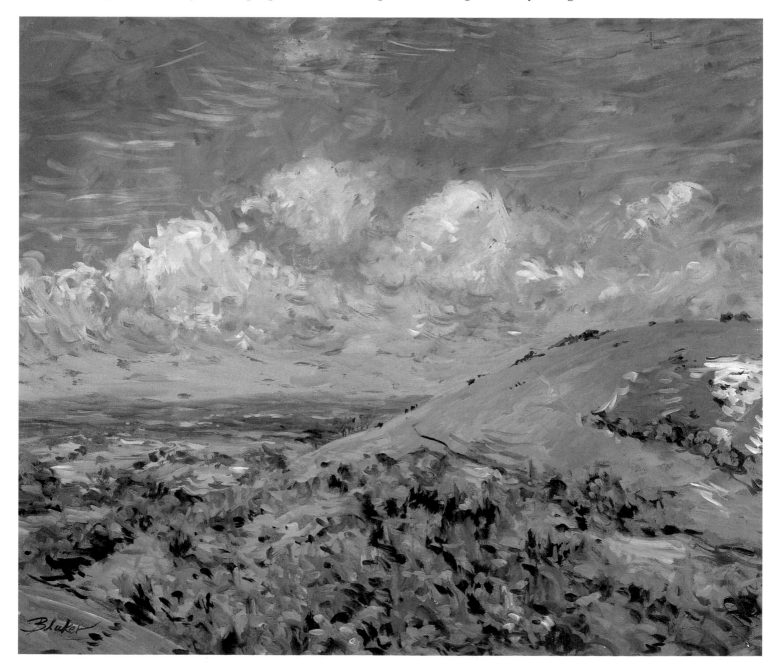

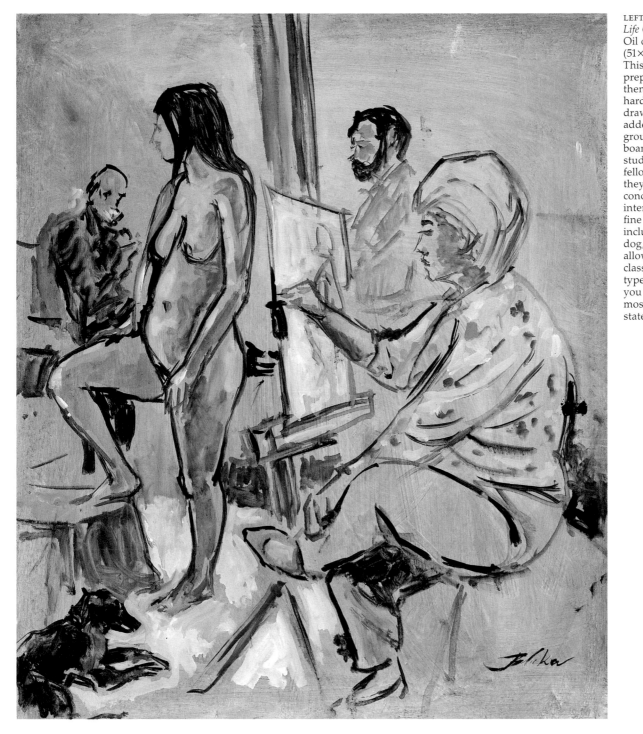

LEFT
Life Group
Oil on board, 24×20 inches
(51×61.5cm)
This is painted on a board
prepared with white and
then lightly tinted, and is
hardly more than a brush
drawing with a little color
added. When working in a
group, keep a supply of
boards handy for making
studies like this of your
fellow artists; the positions
they adopt while
concentrating can be very
interesting and can make
fine compositions – even
including the model's little
dog, which has been
allowed to stay with the
class. You can elaborate this
type of painting or not, as
you wish; often they are
most effective left in their
state of immediacy.

ally building up their oils. The rule is always to work from lean to fat: each succeeding scumbled coat should be composed of a slightly thicker mix of paint. If it is thinner, it will dry before the surface below is thoroughly dry, and the lower surface drying later will contract and split the upper layer. One may paint when the lower surface is apparently dry, but for thick oil paint really to dry takes several years. The overpainting and scumbling technique is one that you will achieve by experience; otherwise, you will find that areas of the picture are cracked and crazed. To lay a *flat* level surface over an already painted area is of course rather pointless, if you are not making use of the color below to show through.

There may be times when you wish to alter an area already dry. It is best to remove this completely, with a little cotton wool, employing a mixture of half acetone and half pure alcohol (made up by a pharmacist) but you are venturing into the professional world of the restorer here. Better not to alter, but to decide what you want in the first place and work steadily to that result. Endless hopeful dabbing at an oil painting is a mistake. Those who say that the advantage of oils is that you can always alter them are following the wrong line of thought. You can more easily kill the life and surface of oils by messing about than with any other medium; good painting has a life and character to it, an authoritative sparkle.

Although I have suggested the use of commercial white undercoat, remember not to use gloss paint at all. This, having a high varnish content, has a shine that will throw off a subsequent layer, as here is no tooth (or slightly gritty or matt surface) for another, later, coat to get a grip on. The old Victorian house-painters in fact used to talc or chalk-powder a door to which they were giving a second coat, in order to create a slight tooth for the succeeding coat, and also to see what they had not so far covered as they worked. It is important to note always that you should not paint on a shiny surface, only a matt one, and then preferably only with thicker paint and a slightly broken touch.

Regarding canvases, if the canvas is too thin or merely a cotton one, it will soon have dents in it as people often lean canvases thoughtlessly against the corners of chairs and tables, so poking the surface out in front. It is surprising how often the average person will do this. The traditional cure is simply to spit on the back, and the canvas will dry and pull the dent back into position. A little water on a rag will do the same, but if you overdo it the 'size' of the original stretching will be affected and will throw off the ground. So be careful!

When cleaning an old painting, one of your own, perhaps, that has gone a bit dull or been subjected to the grime and dust of humidity while hanging on the wall, it is important to avoid the use of water, as this will seep down to the ground and possibly even affect the size, leading to mold or fungus. And no half-potatoes rubbed over the surface, either, as recommended by one ancient *Household Tips*! There is really not too much that you can safely do. Mineral/white spirit may well remove or melt some thin part of the paint somewhere. The professional restorer will roll small tubes of cotton wool, wetted with a minimum of the acetone and alcohol preparation, slowly across the surface and stop when they pick up the least touch of color – but all this is another art.

Perhaps the best method is to lightly dust the surface and, with the very least mineral/white spirit on a piece of cotton wool, most delicately work on the surface. You can then re-varnish when completely dry. The new synthetic varnishes are perfectly colorless and can be easily removed with spirit at a later date if necessary. To use an old-fashioned heavy copal varnish is almost to lock the painting up for ever. Although anything can be cleaned and restored by an expert, on the other hand much can be

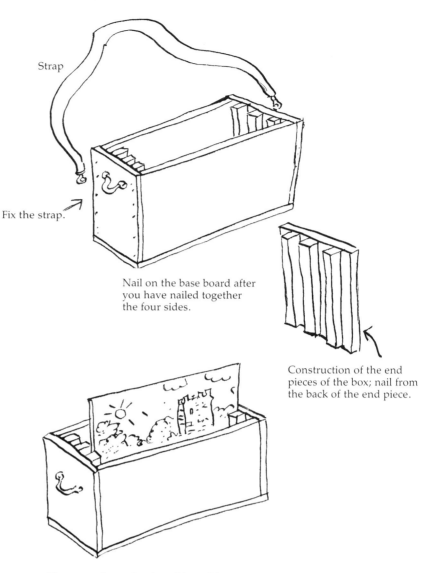

Nail on the base board after you have nailed together the four sides.

Construction of the end pieces of the box; nail from the back of the end piece.

Three panels can be slotted in and kept separate from each other; a lid, hinged on one side, may be fitted. Cut the panels to fit so that they slide in easily. For larger pieces of panel, make a box that will accommodate two pieces only so that it is not too heavy.

ABOVE
Making a Case for Carrying Panels
If you regularly work on more than one canvas or board at a time, it is useful to have a suitably sized container, both for ease of carrying and to protect your work.

damaged in cleaning and require re-touching, particularly areas that perhaps are hardly covered with paint at all. After all, with painting you are not aiming at a linoleum-like consistency of surface; you are not a decorator.

Traditionally, varnishing was the final completion of the painting, particularly in the days when paintings were often full of deep black shadows that could dry out as rather matt and dull. The varnishing brought back life and vivacity with its high gloss and sheen. Varnish is a solution of gum and spirit which provides a transparent layer, rather like a thin piece of glass. It protects a picure to some extent, although when cleaned off an old painting in order to reveal the bright colors beneath, it can take off some final glazes with it. From the time of the Impressionists, with their use of glittering shimmering colors and lack of deep black theatrical effects, there has been little

point in varnish; in fact, with its tendency to darken with time, it is more of a hindrance to brightness.

If you do wish to varnish a picture – and there are pictures which improve with it – you must wait six months for the paint to be really dry. This age-old precept applies primarily to the thicker areas of paint, such as those applied with a knife. A thin-painted area could be varnished almost as soon as the surface is dry. Nevertheless, err on the side of caution. There are various varnishes available from arts material stores. The old ones were mastic, dammar and copal (which are rather too deep and dark) but the newer synthetic resin varnishes are colorless, and are also easy to remove when required with mineral/white spirit. Lay on evenly with a wide brush and do not retouch. Do not varnish on rainy or misty days. The surface of the painting must not be at all damp or 'bloom' will appear – a white fungoid growth. The eighteenth-century artist used vinegar to kill this. It works, but is a drastic method. Few restorers of valuable pictures would advocate it!

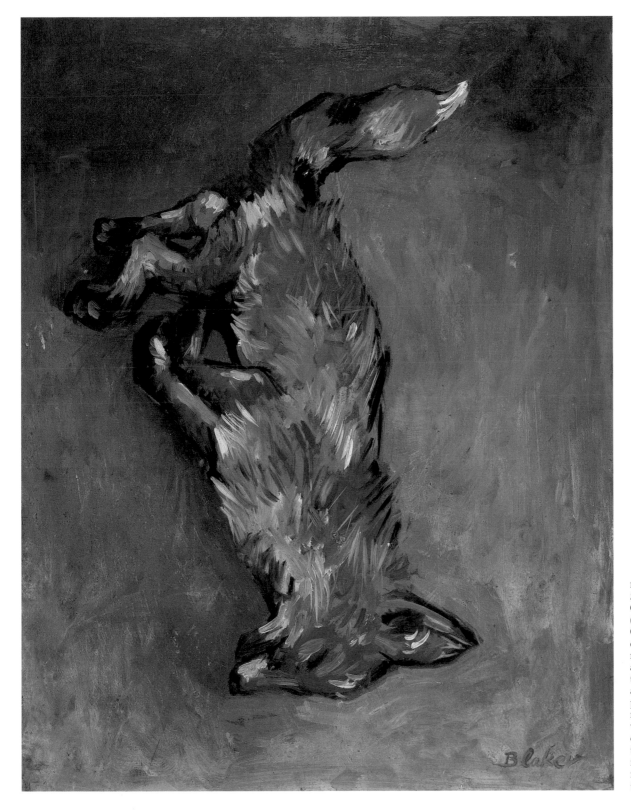

LEFT
Study of a Dead Fox
Oil on board, 20×16 inches (51×41cm)
Occasionally you may find dead animals by the roadside, and you can learn a lot, both about the treatment of fur and about anatomy generally, by painting them. Foxes are a marvelous red color that varies from pale yellowy-orange to black. Do not try to paint hair by hair but go for a broad effect, using a medium-sized brush rather than your smallest one.

3. A First Landscape

It is as well if we find a subject that is not too much of a wide-screen panorama, but simply a few trees and a hedge with a shed or barn. Of course the subject must appeal to you, but do not give yourself too much detail to concentrate on – you are not making an etching. Detail may best be inserted by suggestion, not by minute delineation; and in painting, your shapes and masses must be in relation to one another. One does not paint an Impressionist meadow and then paint in tiny detailed figures with a minute brush. Ideally use one brush, or at most two, for the whole picture. With a small panel, a number four or six sable and a large brush on hand for the sky, you should usually be able to complete the picture. There is no need to paint too thickly, certainly not with your first touches. Nor should you aim immediately to paint with the brightest effect, even if sunlight is drenching the scene. Van Gogh may have used thick paint straight from the tube, but he was subsidized by his brother and could order whatever paints he needed to be sent to him from Paris! Incidentally, he mixed them with wax to keep them from shrinking in the drying, being a consummate technician. The image of Kirk Douglas painting in a wild fury outdoors is not probably quite the truth, as Van Gogh frequently painted indoors from large pen-and-ink studies made on the spot, which may account for the calligraphic feel of his style. The twentieth-century English painter John Bratby, who painted marvelously with a more than Van Gogh-like spontaneity, neglected to mix his oils with wax, so that over the years the great sacs of paint squeezed directly from the tube have shrunk and shriveled in the drying, like paint on an old palette.

But today we are in front of our subject,

and the sunlight is playing upon it with a shimmering effect. We cannot paint here by the values as they are not even static. We have at most four hours to finish, before morning turns to afternoon and it is a different picture altogether. We must, however, remember the values of tone and contrast. Tone and contrast are highly important to the painter. Even when using the brightest color, you should think in terms of the range of contrasts which there are in the tones between black and white: two extremes between which there are endless graduations of tone, as in an old black-and-white landscape photograph. You must decide whether the blue in a sky is a deep tone or a pale tone, and how it goes with tones of the other colors in your picture. It can be a useful exercise to make a painting from the view in front of you entirely in

FAR LEFT
The Overgrown Avenue
Oil on board, 20×24 inches
(51×61.5cm)

BELOW
Birch Tree at Fittleworth
Oil on board, 20×24 inches
(51×61.5cm)
The scintillating leaves of the small birch contrast with the somber pines behind.

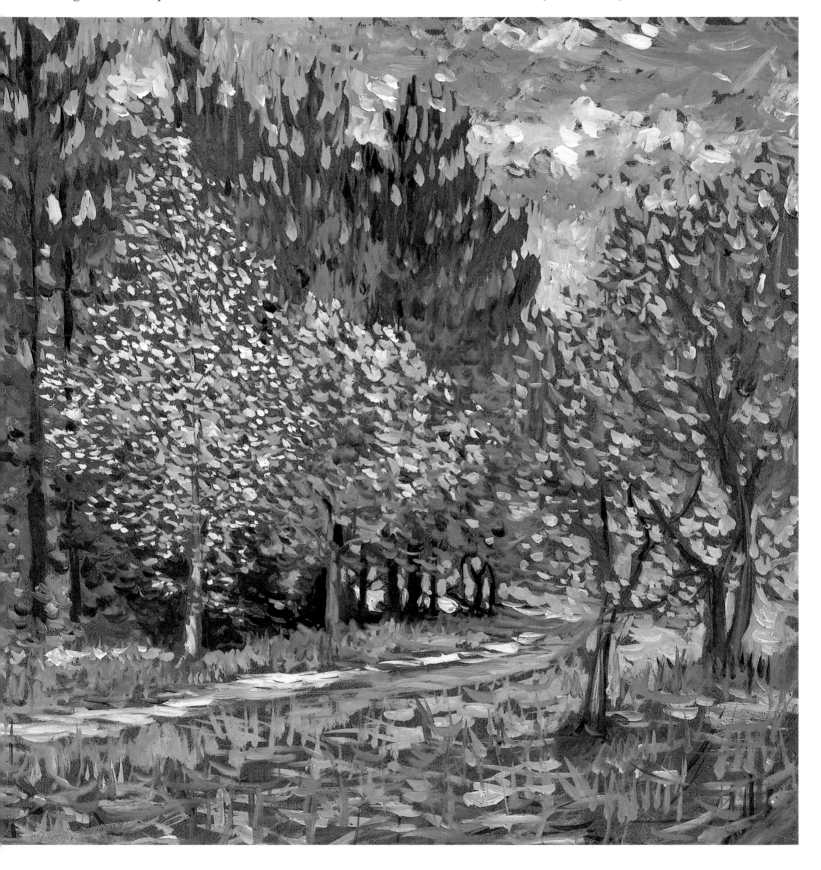

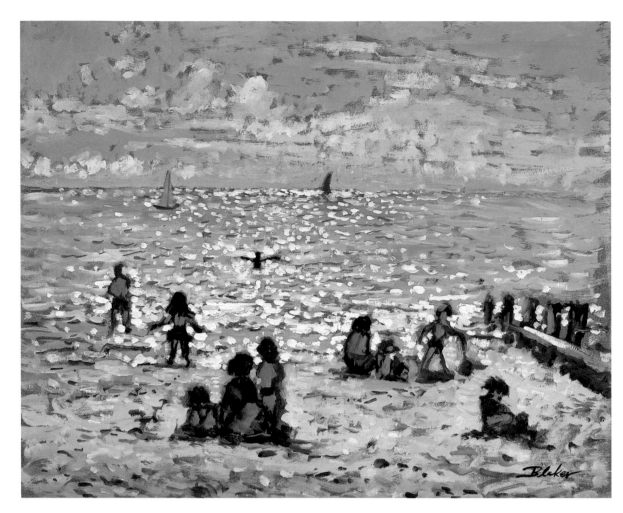

LEFT
Sunlight on Water
Oil on board, 20×24 inches
(51×61.5cm)
The effect of the golden
light here is to deprive the
figures of their local color,
so that they take on a lilac
hue. Be careful not to make
them too dark in tone, as
they are also picking up
light from the variety of
reflections created by the
intense illumination.

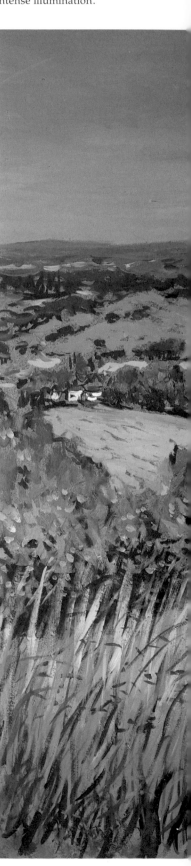

black and white, using no other colors. You will find that tone and contrast are all, and this will teach you a great deal.

It is also important to remember that if you make all your touches brilliant complementary colors, such as a bright red always next to a bright blue or green, they will cancel each other out rather than intensifying the effect. Such a theory works with light, perhaps, and it works when we make a film of a painting that has used these colors, or project the photographed image as a transparency; but the picture itself may often disappoint those accustomed to the stained-glass like brilliance of a painting known only in reproduction, when eventually they see the original. Gauguin's paintings, for instance, are surprisingly matt.

So let us think now of nothing but what is before us, having hopefully stored all these points in the subconscious. There is, we note, a deep blue-black shadow under that tree. Take your brush, and with some of the blue-black, made inkily watery with paint thinner, sketch it in freely, adding the tree trunk, the branches, and some of the darker leaves. Try to write it down, as it were, as if you are describing how a tree grows to someone: there's a stem here, you see, and then a shadow goes under it like this, and

then there's another bit of fence leaning like that. Say this as you note it all down, describing the scene to yourself, even out loud if you want, like counting the timing to music you are playing; it will keep your speed going at a good regular pace. If you feel you are getting a bit stuck somewhere, leave it: go somewhere else in the picture. Do not rub it out or aim to alter it from lack of confidence; you must not lose your nerve. You must keep the life going in it. That is the most important thing.

Now, you have it all noted down, with some dark shadows here and there. Half-close your eyes at intervals to pull the tones closer together and make the image simpler. Then take a slightly larger brush, and put in a more mid-greenish tone: white undercoat mixed with umber, blue and a little yellow perhaps. Mass it where you can see little detail, inserting flickering notes with a smaller brush for the leaves. As you work, you will gain confidence and become stronger, more assertive, and use a more loaded brush, that is, with more paint on it each time.

Now for the sunlight; here is some fun. Wash your brushes, and change the paint thinner you use for washing the brushes regularly. Tip it out and refill. Mix some

yellow and white undercoat, with perhaps a little blue-black and umber. You don't want to use all your big guns at once; keep back some reserves. Flicker the sunlight color about just where you see it. If you have a barn or shed in the composition, put in the shadowy bit with umber and white; then, with the yellowy tone, put in the light parts. This direct method is called *premier coup*, and you should always leave this, the first touch, to stand. You do not need to obliterate your first touches, merely add to them with a lighter one. Finally, you can bring out the fiercest bright touches of sun with some pure Flake White mixed with yellow, and use the palette knife to apply these direct touches where they seem brightest. Do not hesitate or retouch; think of it not as paint, but as sunlight. Always keep your eye mainly on the scene before you and do not

BELOW
A View of Poynings and the Sussex Weald
Oil on board, 20×24 inches (51×61.5cm)
This is an extensive panorama that could not be treated as a quick atmosphere sketch because I wanted it to be an accurate portrait of the place.

mess about with the picture, but keep it always fresh and living. The foreground can be massed-in with its basic color, but should be varied with touches of different tones for grasses etc.

The sky is what will pull everything together now. Mix up the tone you think it is with white undercoat and blue. If there are clouds, put these in first. Do not try to model their form too much with added umber or gray. Add thicker Flake White with your knife to bring out the lights; this will itself give modeling. The tone of clouds is faint compared with the darkness of trees and buildings. Hold a black pocket comb before your eyes and look at the tone of the sky and clouds in comparison. You will see that it hardly exists; they are almost flat (storm clouds are of course another matter).

Regarding tones, eighteenth-century connoisseurs would carry with them a deeply-toned and tinted piece of glass in a frame, in order to look at nature reduced to the style and image of paintings fashionable in that era. It was called a Claude Glass, with the idea that it approximated to that painter's vision. It is doubtful whether artists used it much, I would think; but at least it would make one aware of the tones. I myself would not, however, suggest that you either painted or looked at your subject wearing sunglasses.

Your study is now finished, and it is important not to tinker with it. The moment that you feel it is almost finished, needs just one more touch – it *is* finished. You must not make that one more touch! Many a good painting has been ruined that way. The master is he who knows when to stop. It is a rare accomplishment, to know when you have made your statement and that anything further said will weaken it; but this can be learnt. The moment that this thought of the last touch occurs, you have in fact come back to earth: you are detached from this long concentration, or the thought would not have come to you. The bravura British painter Augustus John (1878-1961) would spoil any picture if he could. To prevent this, his family would grab them off the easel and run off with them. If he could, he would try to go on with pictures forever in the attempt to improve them. Do not do this; paint a new picture. And never destroy your work, even if you don't like it. Keep a box in the attic and put your doubtfuls in it and look at them five years later when you have forgotten them. Then make your judgment.

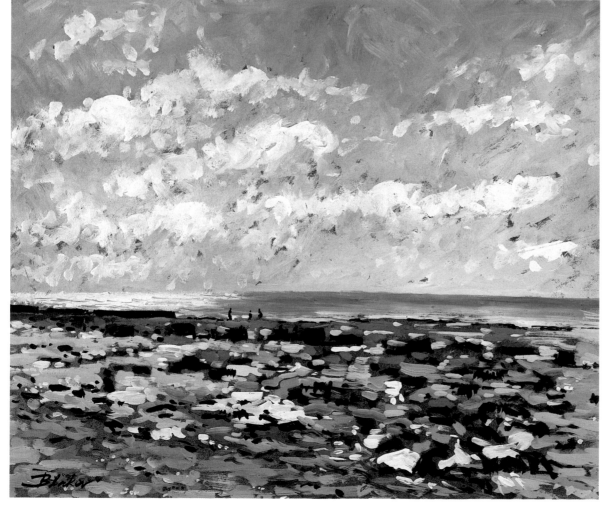

LEFT
Rocks and Sea
Oil on board, 20×24 inches (51×61.5cm)
This area of rock pools, green weed and white chalk makes an abstraction of the scene, which is enjoyable to paint because of its constant contrast. A fairly lively day, with plenty of sun and wind.

RIGHT
Morning on the Medway (detail)
Oil on board, 20×24 inches (51×61.5cm)
This is a morning effect, with the sun just beginning to pick out lights on water, houses, and distant smoke from factory chimneys. The pleasure of water is that it reflects the landscape and is also ever-changing, so you have to be quick.

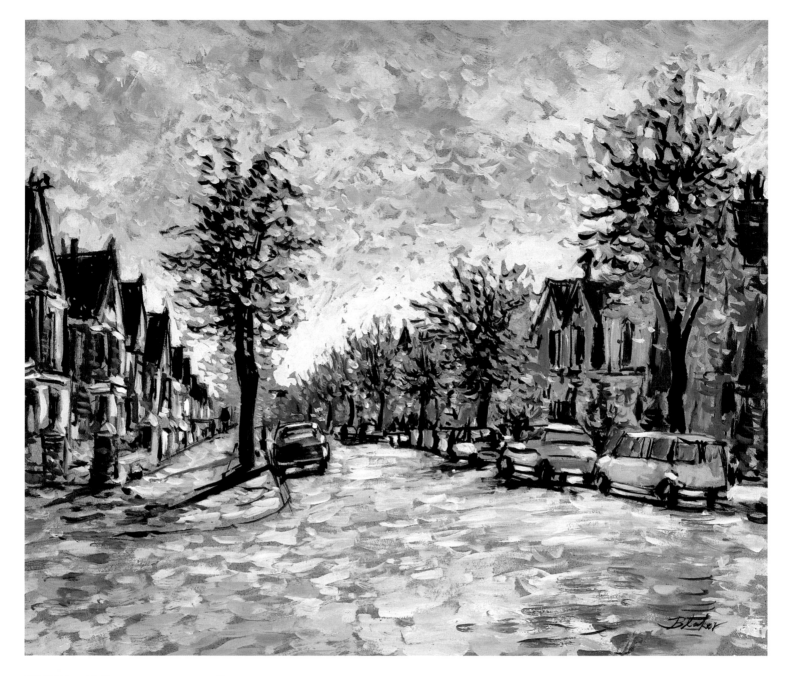

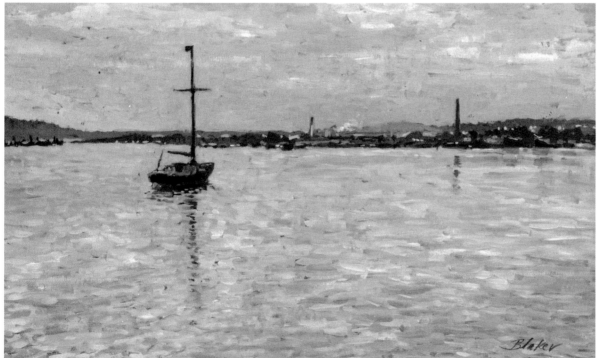

ABOVE
Late Summer Afternoon, Hove
Oil on board, 20×24 inches
(51×61.5cm)
It is useful experience to
settle down and paint a
street scene. Include the
parked cars; they are part of
the life of the place and
their very everydayness
will become more
picturesque as time goes
by. The extraordinary
golden light that appears
toward September in a
temperate climate is a
fascinating subject,
showering the scene with
an effect of gilded snow.
Paint this in as brightly as it
appears, stepping up the
yellows as strongly as you
wish. We know that roads
are gray, but when
throwing back the glow
from the sky they become
something quite different.

4. Flowers, Fish and Animals

Flower Painting

To some extent, this may be approached in the same way as your first landscape, although as you are nearer to your subject of vase and assorted blooms, you will probably need one of your larger canvases. Make up a good number of these to begin with – take a few days, then you will have them in hand. Once you are under way you will want to carry on while the mood is on you. Set up your vase in a good light, preferably not in sunlight unless this appeals to you a great deal, as it will make it all a bit difficult. It is better to select a varied bouquet of different fairly simple flowers, such as a collection of wild flowers, poppies and the like. As they soon wilt, pick them as buds and they will emerge as you work. Avoid the most beautiful roses at first, as they are such works of art in themselves that they will always outdo you. A variation of specimens also stops you feeling you have already painted that type of bloom sufficiently. It is here that you will need your Alizarin Crimson and your Purple Lake, as there are so many delicate tints. If there is one that you feel is too impossible, aim for the nearest, or take a different flower. It is pointless to search the art stores for a tube that gives the right color; color is a question of observation and mixing. There used to be a tube of paint manufactured called Flesh Tint. This was a joke among art students, who would occasionally send a novice to go and buy one (and ask if he could apply for his Artistic Licence at the same time). Colors should always be mixed on the palette to approximate to what is before you, particularly flesh with its endless variation. Your picture should also be made with the paints you are most used to employing.

Commence by drawing in, not too minutely, salient points of darks and halftones, as when you painted the landscape. Remember when painting the petals that they are light-toned, just as clouds are. Use your black comb held up to see how little contrast there is in the modeling. It is a good idea to paint in the colors fairly flatly without attempting to model the petals, and then mix up the same color with the Flake White and apply it more thickly for the lighter parts, even finally adding touches with a palette knife. Again, with your umber-tinted canvas (or your hardboard base if used as it stands) there is at once a darker background tone for the petals to stand out against.

Your flowers will last several days, and may be added to or replaced when necessary. You can augment the composition with a flower or two laid on the table that the vase stands on, or even with the odd apple or orange. These last are very difficult to

BELOW
Autumnal Fruits and Old Man's Beard
Oil on board 16×12 inches (41×31cm)
Wild flowers seem to demand an informal treatment; you must seize the moment as they are only available for a short period. Collect a bunch of whatever attracts you, taking one of each species to build your bouquet. The marvelous red of berries reflects bright yellow highlights.

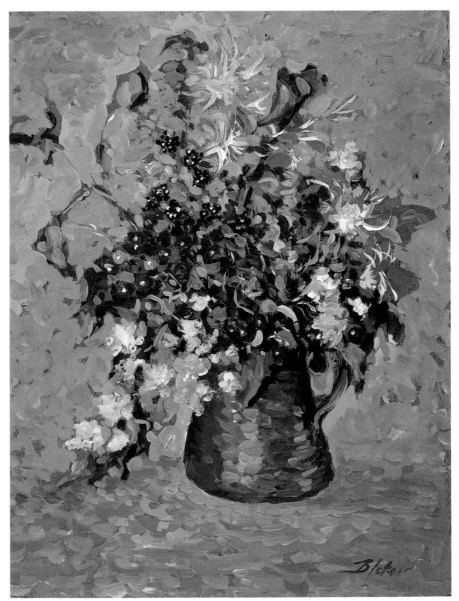

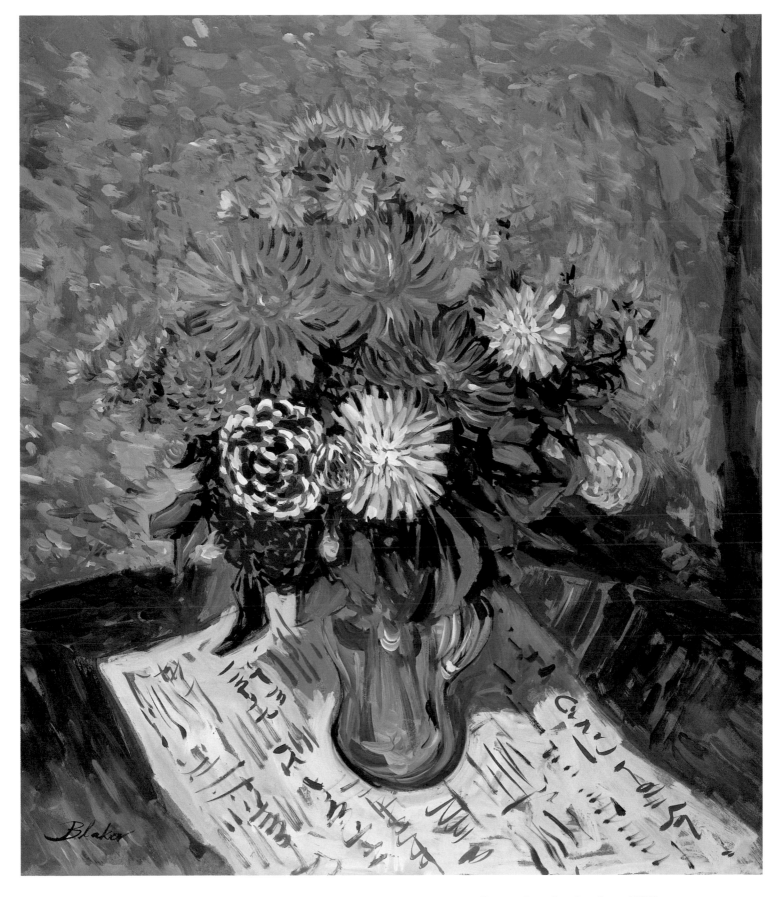

paint; keep to direct touches and do not model the shapes until they become muddy, as fruit, like petals, has a somewhat luminous quality. Again the background, like the sky in a landscape, has an effect upon the tones of the rest of the picture, either making the other items more solid, or flattening them off. You should consider the tone or color that will eventually make the background, and work with it in mind.

There is, of course, another way to paint flowers besides this direct confrontation approach, and that is to build the picture up gradually by painting in a more minute manner, virtually copying (as if copying a painting) each flower in great detail, in the Dutch

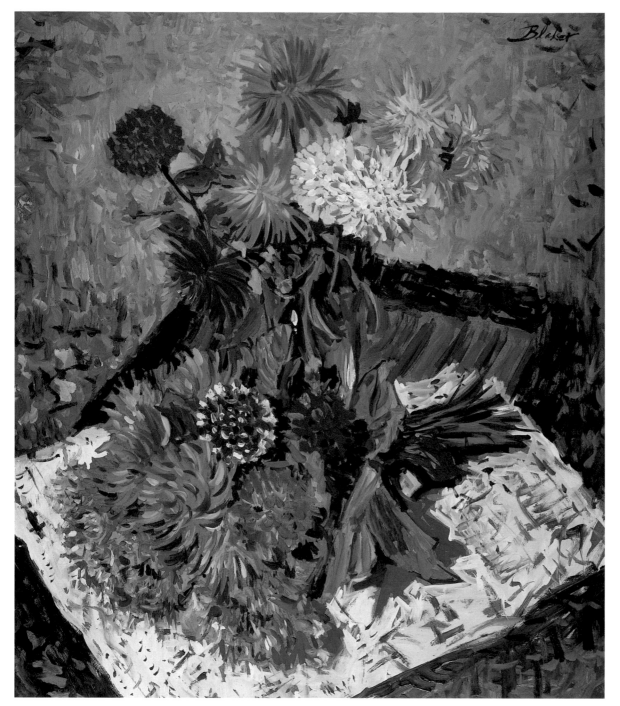

LEFT
Dahlias
Oil on board, 28×24 inches
(62×61.5cm)
Here I have added another
bunch of flowers on the
table to give an even richer
effect. I have given the
background a lesser sparkle
both here and in the
painting on the previous
page, as the flowers are the
important element.

RIGHT
Geraniums
Oil on board, 36×48 inches
(92×123cm)
Plants in pots make good
subjects. Here is another
opportunity to use good,
bright strong-toned colors.

seventeenth-century manner. These Dutch paintings were painted from drawings and constructed slowly, and indeed you could work this way, making a careful pen or pencil drawing, tinting it, and then copying it in with oil paint. This can be enjoyable, and your small brushes will be of use. It is rather different from the approach of trying to express something of the life of the living flowers before you, of course, and does not give much opportunity for the individual hand-writing, so to speak, of the artist to emerge.

Landscape can also be painted from drawings and studies, but I think you will always *learn* more working from life. I myself enjoy painting flowers both in the direct impressionist way, before they wilt, and also in the

very detailed manner, virtually copying each bloom one by one. I would not myself wish to work from drawings, because a flower is such a living creation that it does seem too many steps away from reality to achieve a convincing quality. Even in a composition worked from preliminary material I would prefer to work from real flowers if they are to be included.

It is also an idea to paint flowers as they are growing, and I have painted very many garden pictures, mainly on large 5×4 foot sheets of unprimed hardboard, which give me the chance to be big, bold, and freely direct. Each year I intentionally plant beds and sections of our quite large garden in order to have these subjects to hand as they appear. Sunflowers particularly are an

RIGHT
Chrysanthemums in a Green Vase
Oil on board, 28×24 inches
(72×61.5cm)
This is a darker picture with
a deep background,
allowing the paler flowers
to shine out more fully.

FAR RIGHT
Flowers and Garden Furniture
Oil on board, 48×36 inches
(123×92cm)
A similar subject; the
possible combinations of
pot plants, garden chairs
and garden plants are
endless, and you can add a
sitter if you wish.

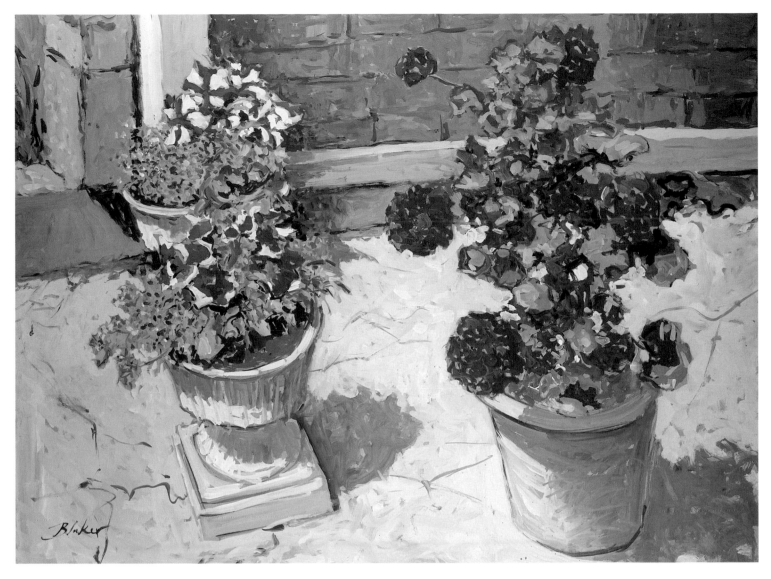

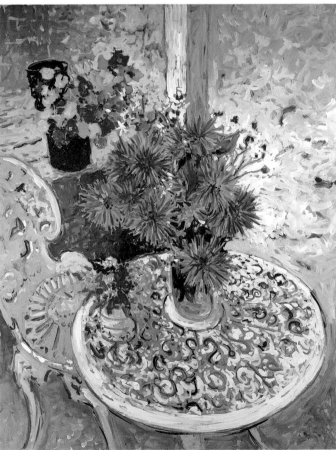

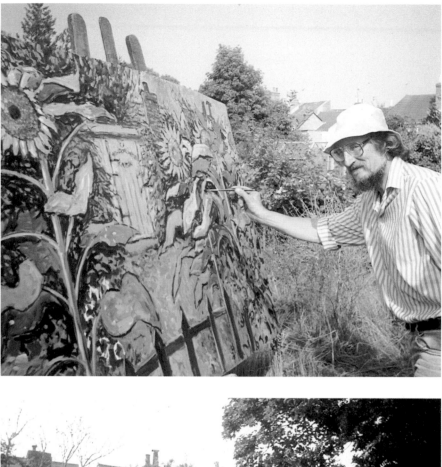

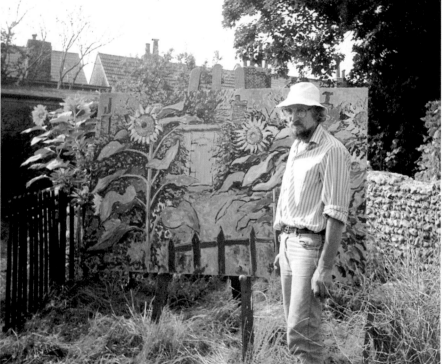

artist's pleasure, and Van Gogh was not the first; there is, oddly enough, a Van Dyck self-portrait with a sunflower. The varying banks of glowing blue borage, pink lavatera, strongly contrasting poppies, all bespeckled with little yellow wild flowers and occasional dandelions, make a tapestry-like panorama which I like to treat almost as a living abstract, simply throwing in the shapes and colors with a confident hope that they will hang together somehow.

The early tulips are very enjoyable to paint in this direct lifesize manner. You feel you are creating them as much as painting them; and tulips in particular alter their appearance so much in their fairly long flower life as to be almost a different kind of flower in the end. Then there are geraniums in pots, marigolds . . . all can be combined in a garden with furniture, people and animals. But the main point is the color and scintillation of the flowers, and with this approach you do not need to worry over too much sunshine. You are not, as in a small panel,

having consciously to diminish and select a picture from life. You are pinning down what is in front of you, close up, to the scale of life; and all you have to do is to let yourself go and be as bold and full-toned as possible. Here is where your largest brushes will be useful; on such a scale there is no real need to worry about a careful touch as, when hung on a wall, your picture will have to be seen at a certain distance. Some painting of this sort is good for you, and you will return to a smaller, more considered approach with greater confidence and freedom.

TOP LEFT
Flowers in a Garden
Oil on board, 48×24 inches
(123×61.5cm)
This tall panel of growing plants on a greenish ground has a decorative quality.

ABOVE RIGHT AND ABOVE
The artist painting sunflowers (see page 17)

RIGHT
Garden Furniture and Flowers
Oil on board, 60×48 inches
(154×123cm)

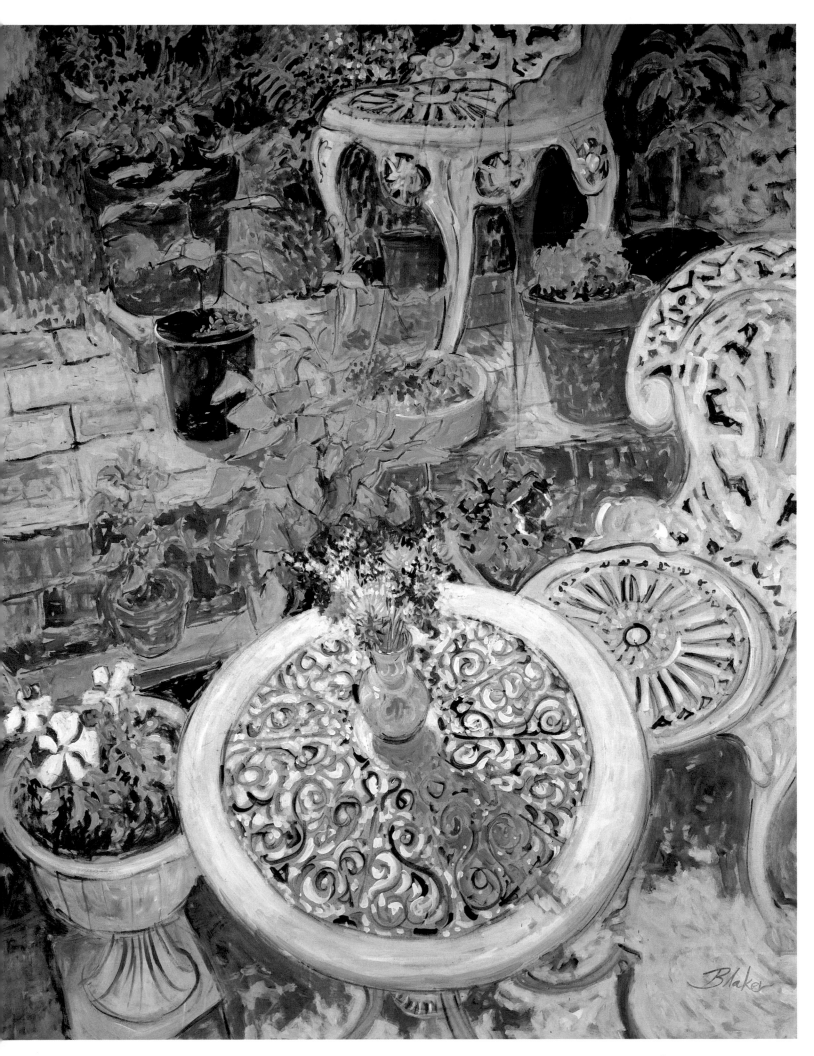

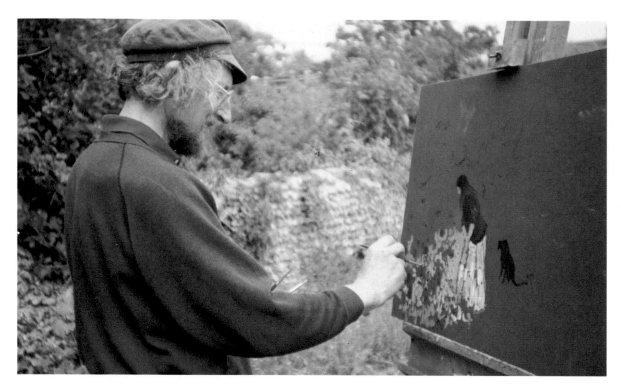

LEFT
This photo shows me starting the picture at right on the unprimed board. The figure has been completely finished and will not be retouched further.

BELOW
Catriona Relaxing in the Garden
Oil on board, 24×28 inches (61.5×72cm)
With such bright sunshine and shadow before you, everything can be put in as strongly as possible. The bright red of the tulips are just as vivid in shadow; the purple and blue notes of the dress need no muting. You will find that you constantly have to step up the sunlight on the grass. The effects can become more intense as the afternoon progresses, the sun takes the dampness and haze from the ground, and the air is clearer.

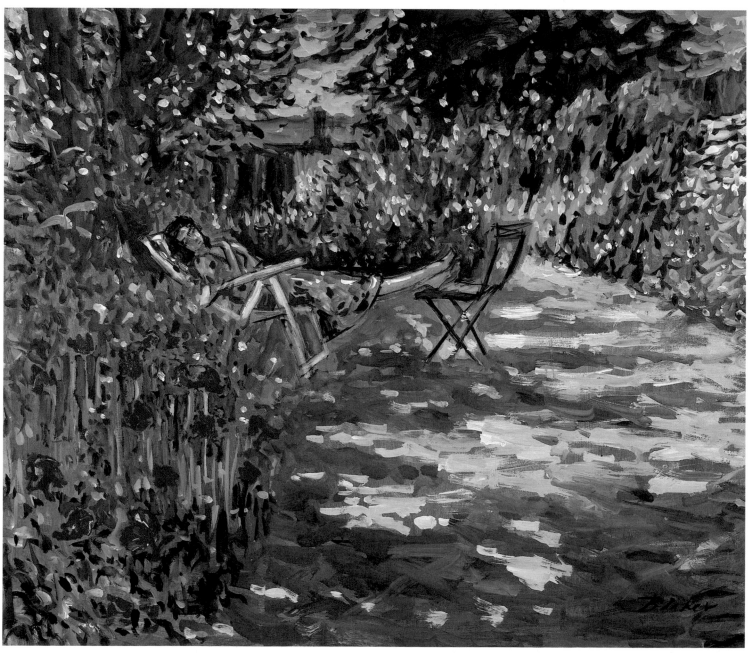

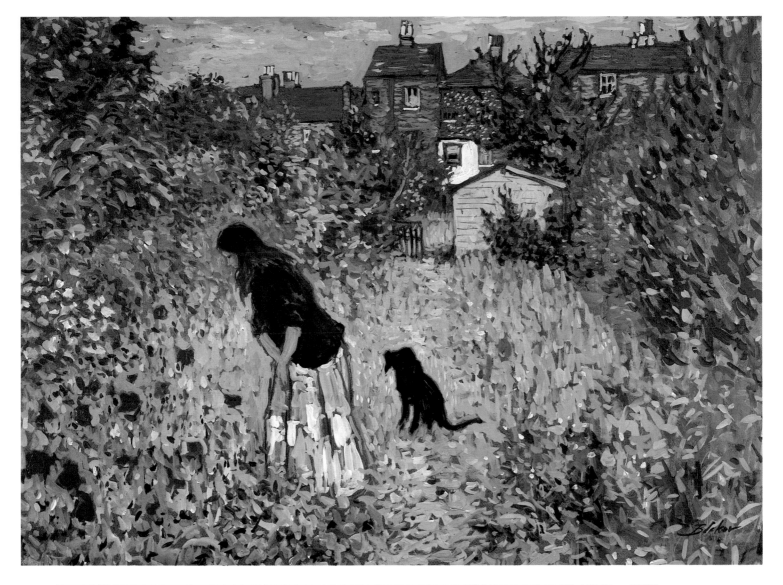

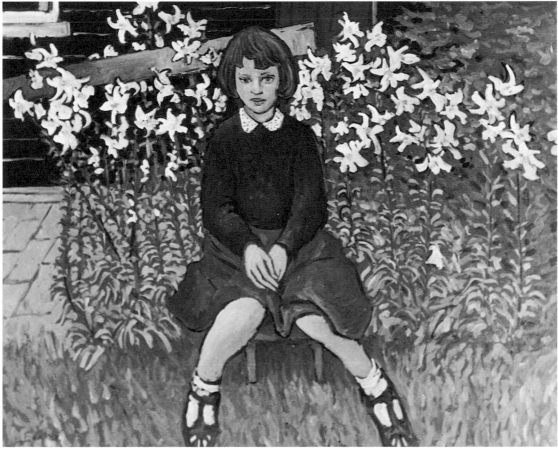

ABOVE
Catriona at the End of the Garden
Oil on board, 20×30 inches
(51×77cm)
This was painted from the figure obligingly posing. Sweep, my black dog, has fortuitously joined the composition, and the red of poppies is always a joy to paint. The background has been worked on after the figures had left; I start with the figures in such a composition and build the rest of the picture round them.

LEFT
Helen and Madonna Lilies
Oil on board, 48×60 inches
(123×154cm)
Flowers also make a marvelous background – or joint motif – for an outdoor portrait. There is a flow of movement between blossoms like waves in the sea; it is important to convey this and not to labor away at one bloom, forgetting the rest. Bear in mind the decorative, tapestry-like elements in a given scene, particularly when painting on a large scale and close-up.

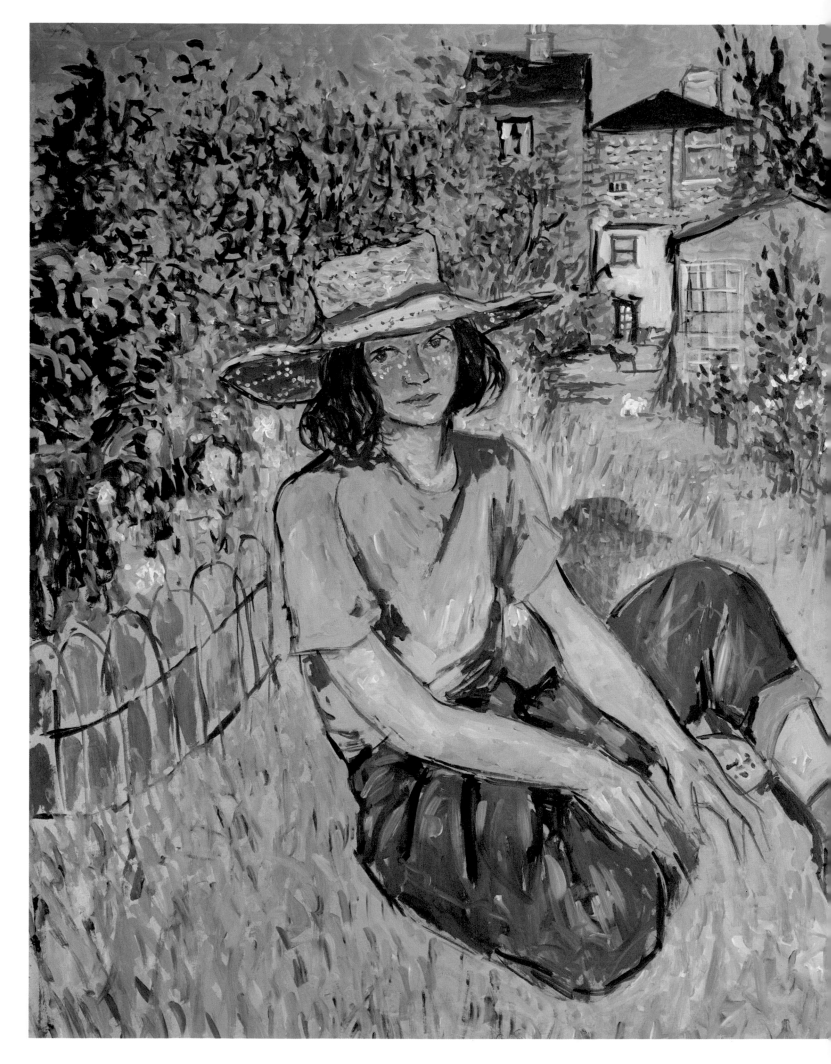

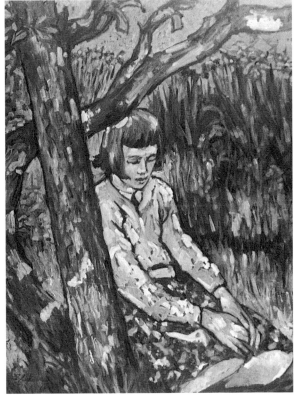

ABOVE
Helen under a Tree
Oil, on board, 60×48
(154×123cm)
The irises at the edge of the
field in the background
were so reminiscent of Van
Gogh that I deliberately
gave a Van Gogh-like feel
to them and to the
treetrunk, piling on the
paint and letting myself go
with the highlights
everywhere: an intoxication
of paint, perhaps, but good
for you now and then.

LEFT
Catriona in the Garden
Oil on board, 48×60 inches
(123×154cm)
The sunlight, shown as
dots of light falling across
the face through the holes
in the straw hat, provided
the real genesis of this
picture. The figure has
become quite monumental,
as I have put in the long
receding garden and
included both dogs as they
happened along. For the
flecks of light to show on
the skin, the face tone had
to be kept low, but it was
important not to lose the
local color, as it was
illuminated by reflected
light from the ground and
clothes. In daylight there is
light in every shadow; the
real blacks (apart from the
deepest shadows of pine or
holly trees) only occur in
artificial light, if then.
Always keep back your
strongest lights and darks
for the deepest tones
possible.

Painting Fish

Here is a subject which by its nature demands a fairly swift approach and is ideal for many reasons. Since the freshness of effect of the dead fish will wear off in about four hours, it is somewhat similar to the transient quality of a landscape weather effect; it is also as easily available. Go down to the fishmonger or supermarket and buy a pair of mackerel, for choice, or three herrings. Remember that you do not want them gutted or the heads off (you can do that yourself later if you want to fry them up after the painting session).

Place the fish on a crumpled newspaper or something of that sort; the lettering will make an interestingly textured background. Do not bother with a plate, or you will waste time trying to get the drawing of the plate right, and it is the fish that you are after.

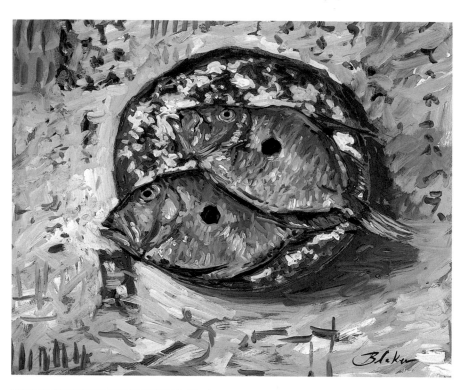

ABOVE
John Doreys
Oil on board, 20×24 inches
(51×61.5cm)
These are diverting fish to paint, with the useful black note of what is reputed to be St Peter's thumb-print. This is a fairly abstract style of composition, viewed from directly above and looking down at the plate set on old newspapers – a good background.

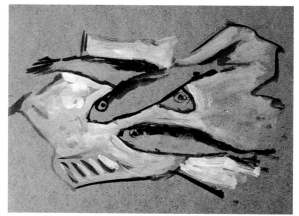
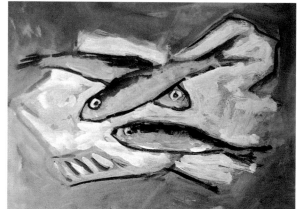

Direct Painting of a Fish Study from Life; a Simplified Approach
FAR LEFT
Line the fish in and add some blue-gray and white.
LEFT
Put in the background and add more white to the newspaper and more gray to the fish.
BELOW LEFT
Add red and yellow notes with the palette knife.

ABOVE RIGHT
Mackerels
Oil on board, 18×20 inches
(46×51cm)
An excellent subject for practicing tonal contrast. All the colors and highlights are applied with a palette knife, while the flattish gray background concentrates the eye on the fish.

RIGHT
Gurnards and Sprats
Oil on board, 20×24 inches
(51×61.5cm)
The pinkish gurnards are a different problem to the silvery, glittering sprats; I have included a plate with blue rings here in order to emphasize the reds in the picture.

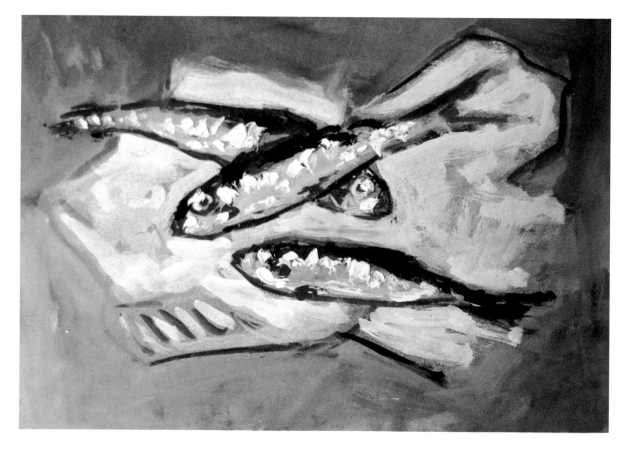

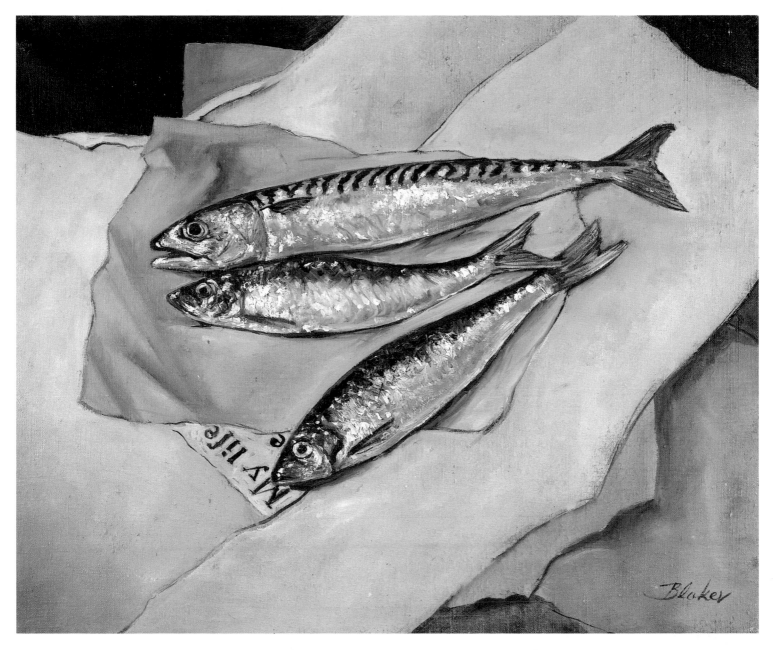

Now, as with the landscape approach, decide where you want the fish on the canvas and begin to sketch in the salient points of greatest darkness. You are not making a rough indication, remember; one does not block in, as they used to say. The right way is to make touches at once that will stand and be important as notes of blackness in the resulting picture. Every touch in a painting must be put there to do a job at once. You do not put in feeble squiggles that are to be later erased, and you never 'rough in'. Look at Lautrec's work: every touch is important and he is also someone who knows when to stop, when it is finished. For fish painting, look at Manet and Sir William Nicholson. Here we have the right swoosh of approach, the kind of dashing brushstroke that almost feels like a fish in water. And here is a point: like the Zen archer himself becoming both arrow and target, think of yourself as inhabiting whatever you paint, as if it *is* you,

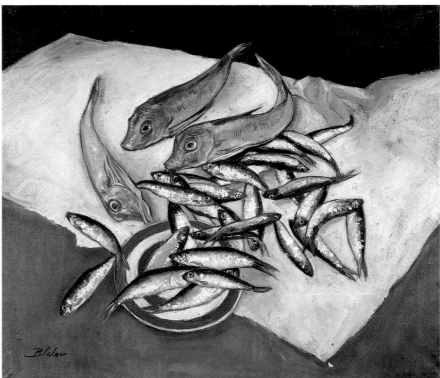

describing yourself *to* yourself (a method particularly suitable for self-portraits!).

Back to the fish, still waiting patiently before you. You will see grayish areas, areas smudged brilliantly both green and blue. Put these colors in, mix them to approximate what you see, thrust them down without hesitation. Now for the bold patterning of the black bars across the backs, particularly if they are mackerel. You may even wish to use your palette knife here, and you need several of these, from the very smallest round-pointed ones upward. There will also be various black and bright red touches to be put in about the fish heads.

Now come those fine bright highlights, the real joy of fish painting. I once had a teacher at art school who said: 'Avoid highlights. They are not form: they are inessentials.' But to me the visual effect before you is what constitutes reality. This is not a piece of sculpture, and a fish *is* its scintillating effect. Once put in, do not poke these highlights about. Use the palette knife and learn to rely on your first touch; this is real *premier coup* painting. The background should not be *too* white, otherwise you will kill the effect of your highlights. This is also real tonal painting. There are other interesting fish for you to paint; try red mullet, or a crab or so . . .

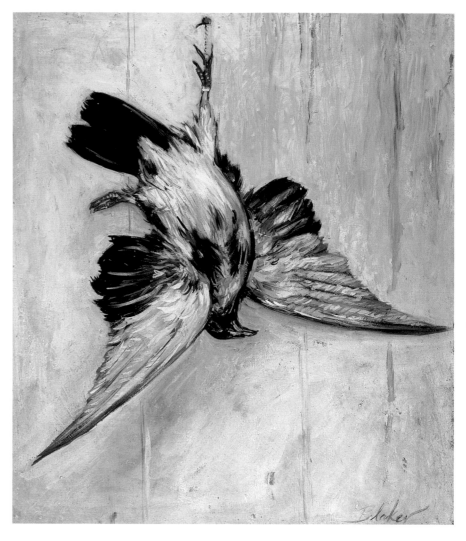

ABOVE
A study of a Dead Bird
Oil on board, 20×18 inches (51×46 inches)
I have hung this up in the traditional way that seventeenth- and eighteenth-century still-life artists adopted to paint such subjects, in order to display the wings. The different types of flight feathers make this a very difficult challenge indeed. If you wish to learn to be an artist, you must make yourself familiar with the anatomy and details of animals and birds as well as of humans. Art is not just a matter of pretty shapes and aesthetics. It is an aid to seeing and understanding the living creatures among which we live and of which we are a part.

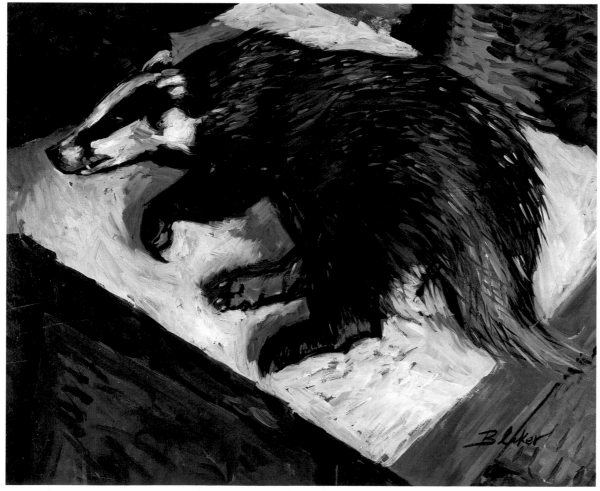

LEFT
Dead Badger 1
Oil on board, 24×28 inches (61.5×72cm)
I have placed the badger on a sheet of white paper on a table in order to make a contrast with the fur, emphasizing lights on both the head and background as they occur.

Still Life

There is a tradition of still-life painting of fruit, pheasants, lobsters, wineglasses and so on, in the seventeenth-century Dutch manner, but I should avoid this school of tightly painted furniture pictures (ordered with the Jacobean tables and chairs as a joint lot). There is something spurious and commercial about this kind of work, and it is not really painting at all. Painting is a response to an object, a person, or even a theme, that thrills you, takes you over, and demands that you paint it. *Real* painting is not responding to commercial demand. That is something else.

There is no reason, of course, why you should not make a direct *painterly* study of dead birds such as pheasants, as well as fish, if you want to and have the opportunity. Certainly they are all fine subjects, and the variety of subject is what keeps your painting fresh and vibrant, even if you tend eventually to gravitate to a favorite one. I have painted small studies of dead birds found in the country, sparrows and thrushes, and once found a dead goldfinch that had been sucked into a train through the corridor window.

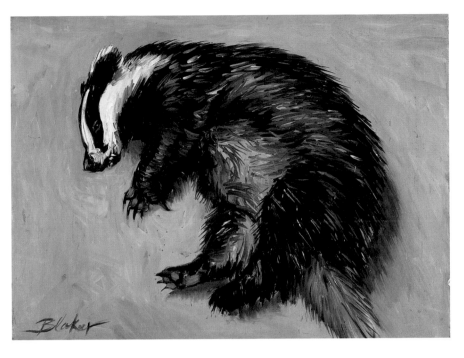

Animals

Of course in all this we must not forget *live* creatures. Now here is an additional problem for you! Bearing in mind all the varied advice and directions for procedure I have been giving so far, you now have another difficulty: animals do not keep still! Your dog, your cat are marvelous subjects, and in

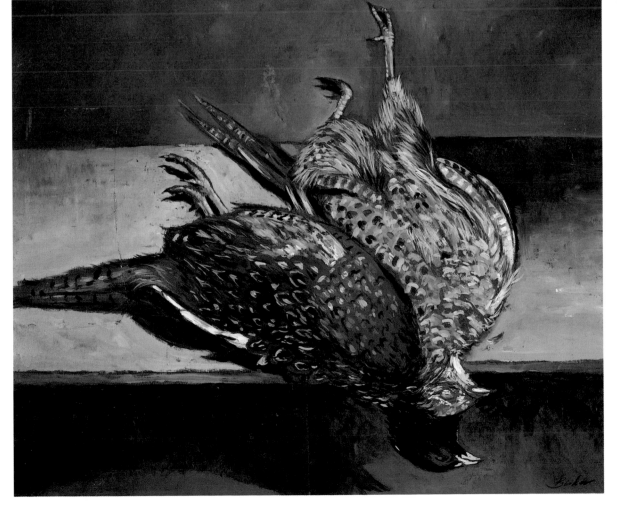

ABOVE
Dead Badger 2
Oil on board, 24×28 inches (61.5×72cm)
The contrast of the black and white markings of the head are very attractive to the artist's eye in this subject. The fur has almost the colors of winter scrubland, going from black to gray and pale ocher. The background in this study is best kept simple to emphasize the variations in the animal's coat. A patterning of grass, leaves, textures and so on could make the whole picture rather a muddle.

LEFT
Pheasants
Oil on plywood, 24×30 inches (61.5×77cm)
These were painted when I was staying in the country and the subject presented itself. The plywood was the only base available at the time but I would not recommend it, as the surface is so very absorbent. I found it necessary to varnish this picture quite heavily in order to bring back the colors.

addition you have the advantage of knowing them so well by daily familiarity, just as a figure painter who has studied anatomy has an added advantage in that he knows thoroughly what is there before him. The cat is perhaps the more obliging subject as, if tired, she will stay curled on a cushion. A dog can be told to *sit*! and will do so for a time, although they do tend to get bored, and get up (annoyingly) to reverse their position. My small Maltese Hero, however, of whom I have made many studies, would obligingly sit for long hours on a cushion and even respond to 'look up!', when his head began to droop, with a look of embarrassed apology. But they are a highly intelligent breed. My black labrador is not so obliging. Nonetheless, when tired he will stay a long time in a basket or on a mat. Animals often come back after a while to their original position, so it is worth having patience. As with fish, work from the darker areas up to the final light tones. The light patches on a black dog's coat will give you some problems if you are to prevent them from looking like gray patches! But these difficulties are very good for a painter to try and resolve; just look at Landseer, if you want to see how to paint a dog's coat!

You may say, why not take some photographs and work from them, as the creatures will keep shifting about so? There is no objection to working from photos, providing that you go about it in the right way. To begin with, your color snapshot will not be the right tone, let alone the right color, so there is no use in sticking it up and copying it. That is not painting. What perhaps you *can* get from it – and I would suggest having a large color duplicate made, a laser enlargement, cheap enough today – is the position, although you will probably have to take a good many snaps in order to find one that is convincing.

It is important also that you take the photos yourself. Somebody else's do not have your memory of the actual occasion or, probably, the actual animal. If you want to carry a camera to record anything that may be useful, do so, but remember that all you are doing is storing information, adding to the memory of what you have actually seen. It is no use simply trying to paint the actual effect of an animal's hair from a photo. The emulsion on a film is sensitive to light effects and the white highlights are of course expanded in a photo, as it takes the impression of them more readily and exaggerates them. It may even tone them down, or darken the

rest of the image to suit them. Photography, even for reference, is an art form in itself, and must be considered as such – it is not reality at all, so be careful.

I may add that I use a camera, I enlarge my own photos, and I compose sitters and photograph them in different costumes to build compositions and subjects from the images. The photograph itself can, in fact, be as much of an inspiration as the sitter. But all this must be done in careful conjunction with the actual person, scene or animal, whom you have to *learn* first from painting from life or studying in the flesh. There are people who pin a color snapshot of their Italian holiday on the easel and dab away happily, learning nothing and creating nothing. If you are inspired by a scene on your holiday and have no time to paint it, walk into it, study it, consider it as if you had your easel and paints with you. *Then* take your photos for reference. But if you want to learn to be an artist who paints in oils, who is able to treat any subject, then work from what is before you.

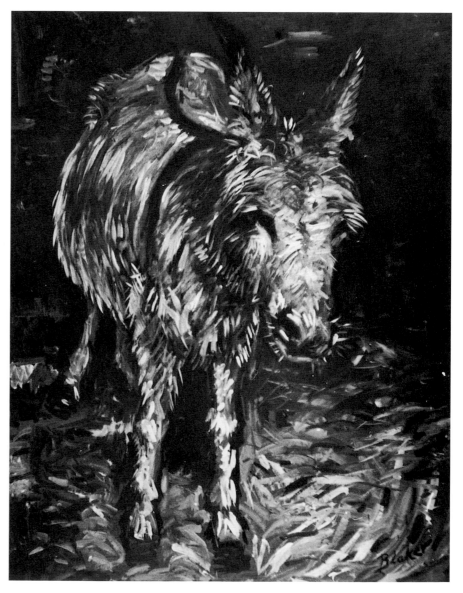

BELOW
Donkey in Stable
Oil on board, 60×48 inches (154×123cm)
Painted lifesize while placidly munching, this donkey was quite a challenge, being a subject I had not previously attempted. The surprisingly large head, the gas-lit effect of light on the coat, the cross on the back, the amazing ears, all contribute to the overall effect. You should always seize the opportunity to paint an animal lifesize, as you learn so much, even if you thought you knew what it looked like.

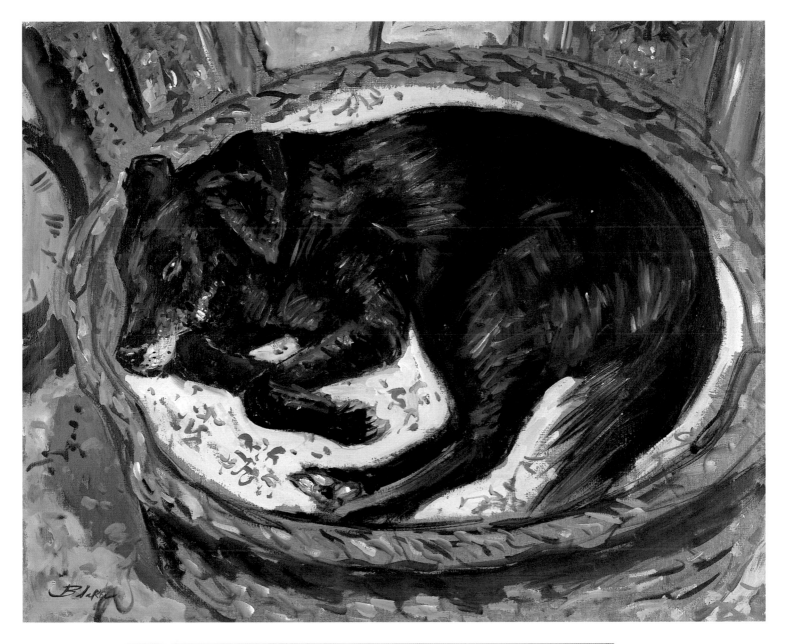

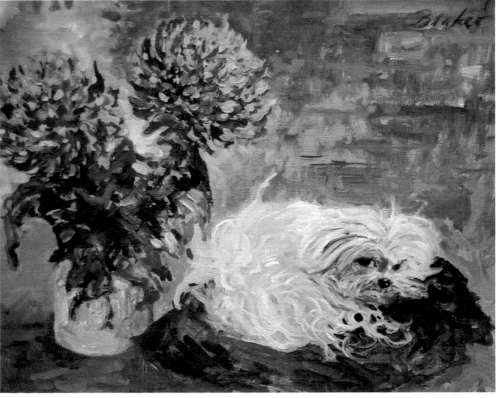

ABOVE
Sweep in his Basket
Oil on board, 36×22 inches
(92×56cm)
The subject was tired and
stayed still for some time,
enabling this picture to be
completed. It is a real
problem to evaluate
correctly the slight sheen
on a black dog's coat. You
can either paint it gray and
then add the blacks, or
paint it black and add the
lights. I prefer the second
approach, but it is
important not to make the
reflected light look like gray
hair.

LEFT
Hero and Chrysanthemums
Oil on board, 18×20 inches
(46×51cm)
The fluffiness of the dog
seems to echo the
exuberance of the flowers;
such similarities and
contrasts can be invaluable
to the artist.

5. Sea and Weather

Beach Painting

In this sphere of our painting activities we are faced with a quite different scene of operations to our peaceful day in the country, uninterrupted, at one with nature. On the beach we have a vibrating, almost hallucinatory, panorama before us. It is a dazzling summer day; there are crowds of people, much going on; the surf is full of moving figures shrieking happily as the tide comes up and down. Speedboats swoop by, towing waterskiers who twinkle against the vivid blue. Golden sunlight bespeckles the water, hovering on the crested wavelets. Farther up on the bright sands bedecked with multicolored towels and sunbeds is a Punch and Judy show, the little crowd of children making this a focal point in the composition. Donkey-riders regularly peram-

bulate their set strip, and the lifeguard on his raised step keeps a lynx eye upon the scene. Well, you have got a subject here!

Firstly, get down in there with it. Take your board, your paints, and your rush mat, your bathing suit, your picnic, your cushions. Find yourself a good pitch and settle into your camp. I would suggest you get down there early, about ten o'clock, before it crowds up. You will then be able to decide on the best point of vantage. Go quite close to the sea, but check whether the tide is going in or out, as this may mean shifting your whole scene of operation. It would be sad if the water came up before you had finished and there was an awful battle with time (and tide), as has certainly happened to me. The main point is to be involved in the scene yourself in order to be able to portray it successfully. Don't make a feature of your-

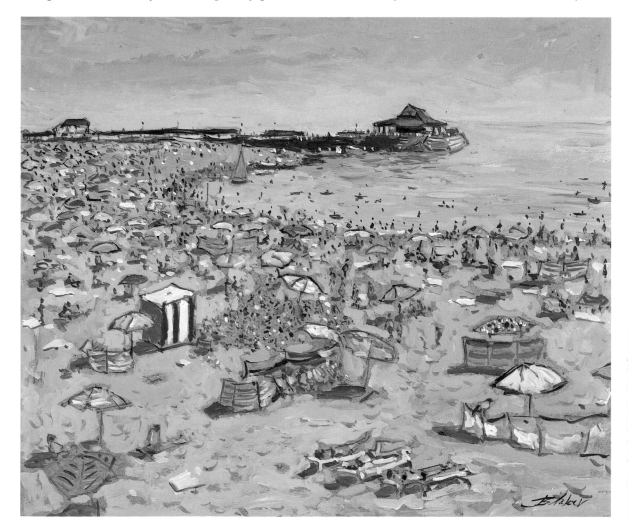

LEFT
Broadstairs Beach with Punch and Judy
Oil on board, 20×24 inches (51×61.5cm)
You need a good summer for this theme. I began with the show and the group of children clustered expectantly around, then put in the umbrellas, color by color, followed with the people, and then worked in the sand around them. The sea and the sky were the final items.

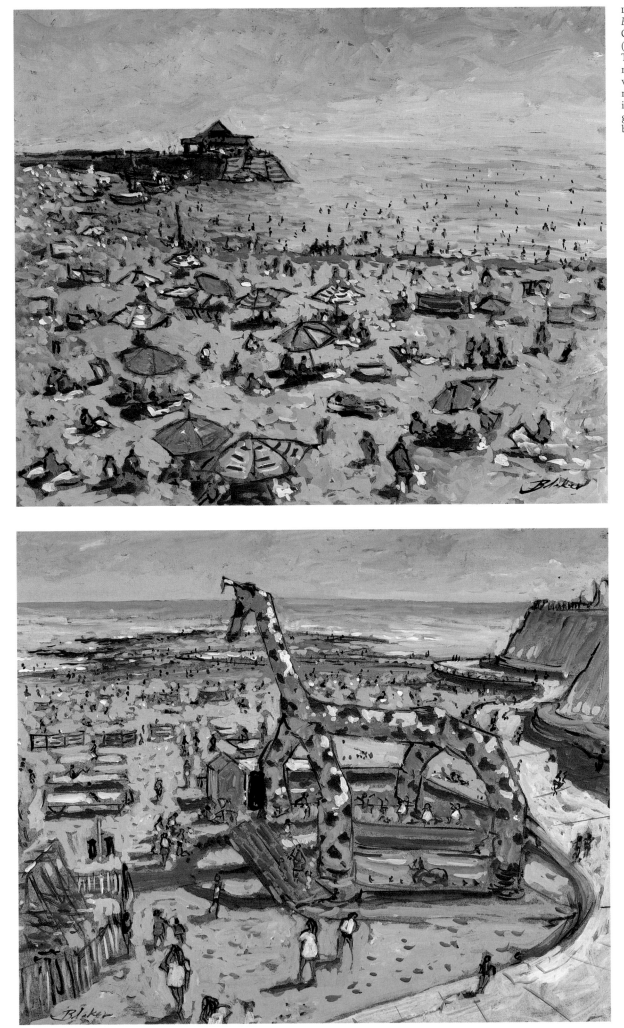

LEFT
Beach Umbrellas
Oil on board, 20×24 inches
(51×61.5cm)
These bright, jewel-like
notes pick up the sunshine
very effectively; their man-
made color makes an
interesting contrast to the
gentler and more subtle
blue of the sea and sky.

LEFT
The Inflated Giraffe
Oil on board, 20×24 inches
(51×61.5cm)
This amazing feature makes
an unusual subject, with
the low tide exposing the
rocks in the background. It
is afternoon, when
shadows are longer and
more emphatic; as people
recede into the distance,
they may be treated just
with single touches of the
brush.

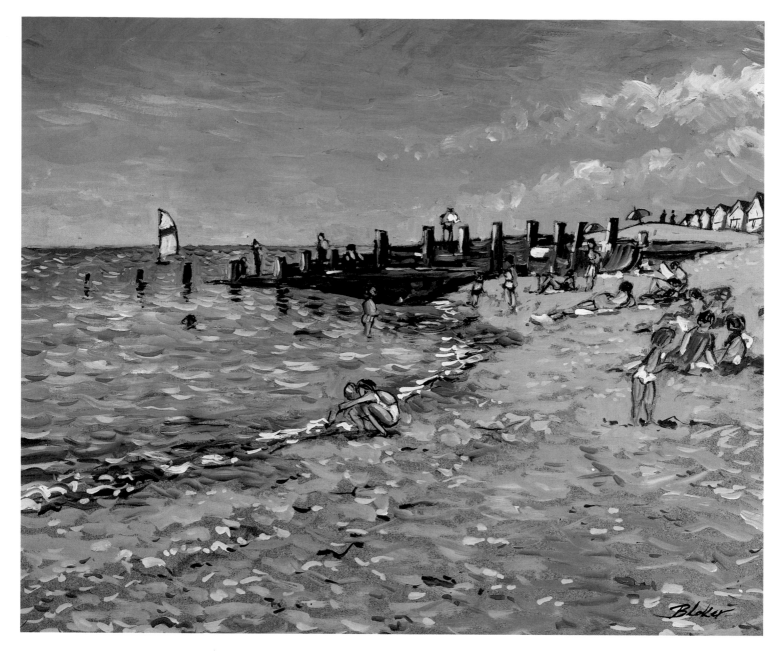

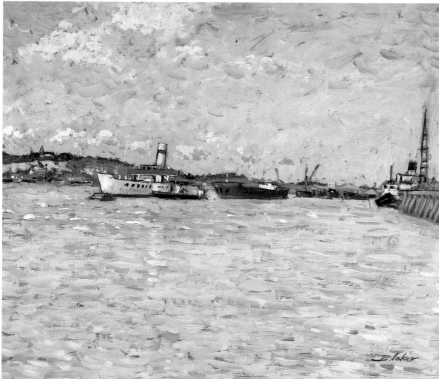

self with an easel, sitting there fully dressed as an observer rather than a participant. You will have half the children on the beach around you in a moment. Settle down, have a sunbathe, then go for a swim, dry off and have a sandwich.

Now, having propped your piece of hardboard up on one of your bags, spread your paints on a sheet of newspaper, sit there on your mat like a Japanese artist, and proceed. Take it all as a definite enjoyment and get the life and frivolity that is there before you into the picture. Flick in your little figures in the surf, with the golden highlights of the waves next to them. Move across the board, here and there, building it up with free touches. Put in dashes of red and blue towels, spreading them about as the decorative little points that they are, and that they make in the composition. Put in the Punch and Judy show booth, and wait for the children to take their places, waiting for the next show.

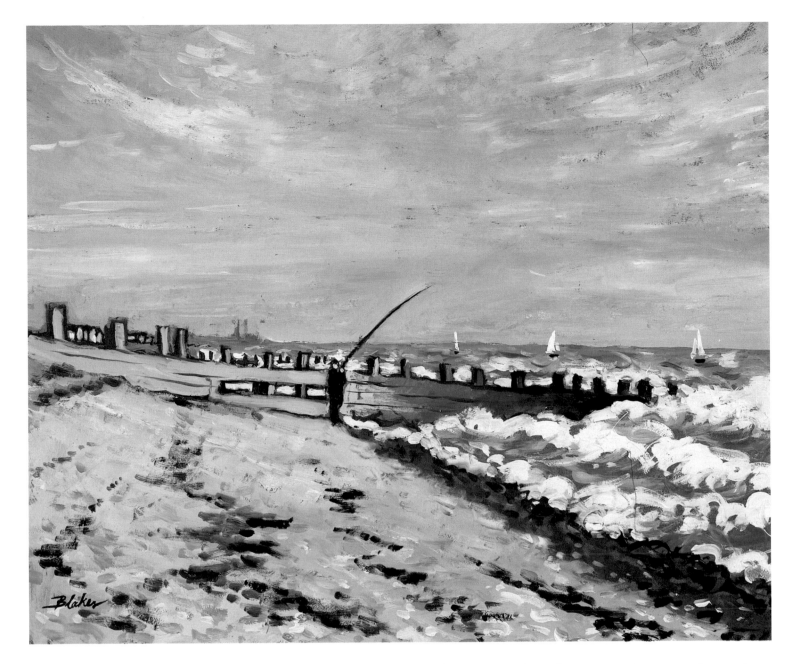

ABOVE LEFT
Summer Beach Scene
Oil on board, 20×24 inches
(51×61.5cm)
This painting conveys a
particularly brilliant effect
of intense morning blue.

ABOVE
Fisherman on the Beach
Oil on board, 20×24 inches
(51×61.5cm)
Another morning subject;
note how there is light
everywhere, bouncing off
the sea to the sky and back
again, while the breeze
creates white waves to
contrast with the sharp
notes of black shadow.

FAR LEFT
Old Steamer
Oil on board, 20×24 inches
(51×61.5cm)
An inspiring piece of water,
with a gentle sun and just
enough wind movement to
disturb the surface and
fleck it with light blues and
white reflections.

Children will of course stop to look at
what you are doing, will sit down beside you
and probably talk. Do not get too fully into
conversation. Be polite, but monosyllabic.
They will get bored after a while, but may re-
turn at intervals to ask 'how's it going?' and
begin to regard you as a kind of possession
to be looked up at intervals. Do not be per-
suaded into 'putting them in.' Just say it's
for somebody else. If adults ask if it is your
profession, say that you do it for fun really,
and they will no longer be impressed and
will go away. One needs to develop a little
tact, but on the whole you will not be
bothered. If you go for another swim, put
your picture back in its case and arrange
your gear in an orderly right-angled man-
ner, as people will not disturb a pattern –
perhaps a race-memory suggests it has
magical powers. You could ask the nearest
responsible-looking adult to keep an eye on
it as well. Put your glasses in your shoe. One

more item in your equipment: a large straw
hat. Weight it with a stone if you go swim-
ming. You can also paint from the prome-
nade looking down to a beach, but be careful
that you do not receive too much of a beating
from the sunshine if is a very hot day. It is
cooler near the water.

This kind of subject, worked at, as I sug-
gest, with a free sparkling touch, will be very
full of the atmosphere of the day once you
get it home. Do not criticize your work to
yourself while on the site. It could hardly be
expected to equal the amazing scene of man
and nature before you; but once seen in dif-
ferent setting, you will find you have cap-
tured much of its quality.

The sea itself is always, in sunlight, of a
blue that hardly needs muting. You will find
in it touches of emerald green. Do not buy
this color or use it, however, as apart from
dubious permanence, it is out of tone with
your other pigments, and a green made

from your own yellow and blue will be entirely adequate. There will also be touches of purple that you should not overstate; the sky meanwhile may be slightly pinkish toward the horizon, if the weather is set fair for sun, or hazy and almost empty of color if a heatwave is imminent. A sharp horizon will suggest poor weather coming up, and the lightness of the sky will throw the picture out of tone, as it has thrown nature. The best days are the hot summery ones with no wind except a slight breeze, and the weather is usually best before 11.30 am. These points should be considered! A good steady hot day will end with a certain sleaziness overtaking the freshness of the morning by about mid-afternoon, when the beach becomes more and more crowded, and the people lose their relaxed air and become slightly stressed with the efforts of watching their children and enduring the sunshine without a hat. You should therefore aim toward leaving the scene by about 3.00 pm. Of course, if you want to hang on until the evening, a different effect will take over as people start to leave and the air becomes slightly fresher. Fishing boats may set out on a calm evening and run a net round a shoal of mackerel that have come too near the shore. This is a good subject for the very quick oil sketcher, as the flipping tails make little sparks of gold on the flat gray surface. You can also buy some cheaply afterward for food or inspiration!

Evenings and Sunsets

Evenings and sunsets are certainly not subjects to be despised, but here you must develop a real sense of decision. No time for second thoughts in any way at all. If you see a sunset effect that you like, and the weather seems set, it is likely that a similar one will follow tomorrow (although no two are definitely *ever* quite the same, amazingly

BELOW
Summer Evening
Oil on board, 20×24 inches
(51×61.5cm)
I had to paint very quickly indeed, at times leaving the mid-tone of the board as background. The whole picture is drawn together by the lights and their reflections.

RIGHT
Sunset on the Medway
Oil on board, 20×24 inches
(51×61.5cm)
This was also painted on the spot but less speedily, as there was not much movement in the sky.

BELOW RIGHT
*Summer Evening with
Lancing College Chapel*
Oil on board, 20×24 inches
(51×61.5cm)
I waited almost an hour for the effect I wanted here, which was well on into the twilight.

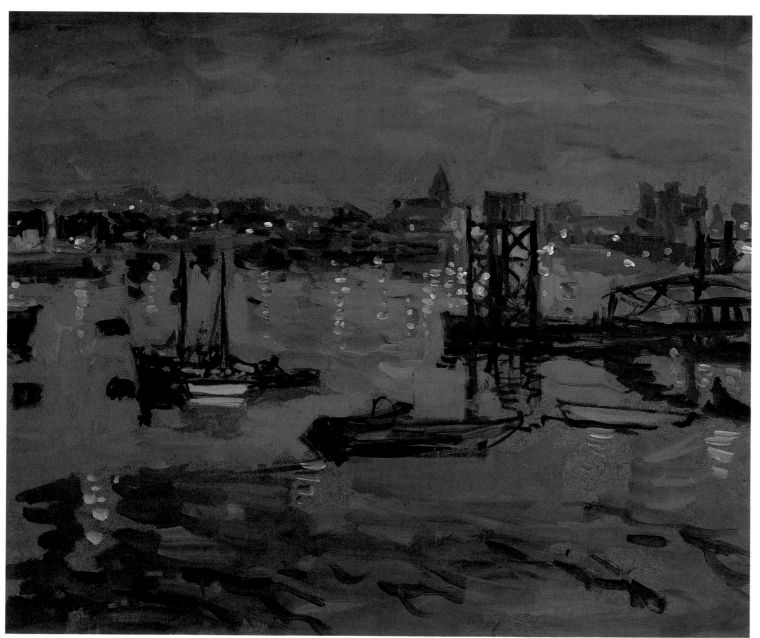

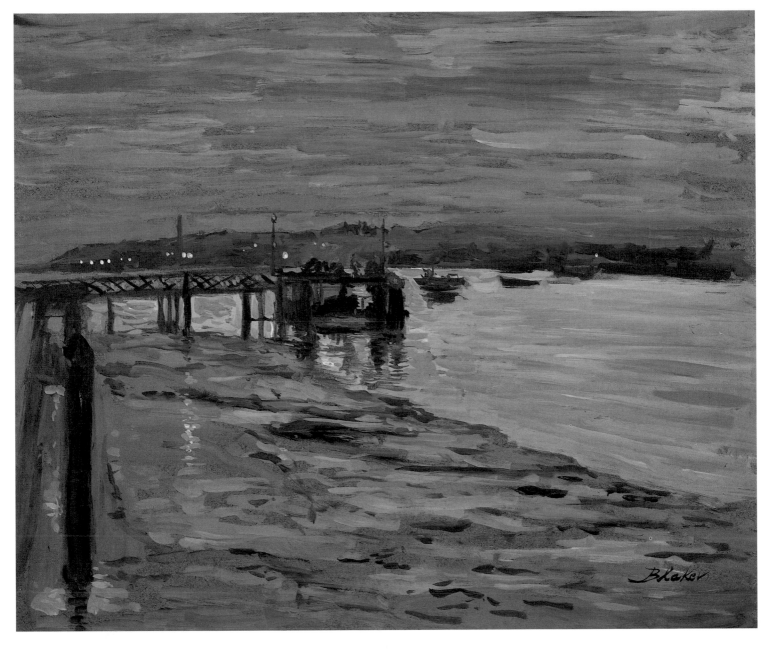

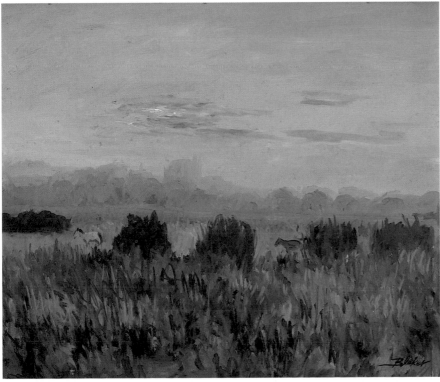

enough). Note the time, and get into place with your gear set up a good half-hour before. Often a subject that includes water is particularly pleasant, as the water seems to hold the light longer. Now, as the moment approaches, begin to dash in your darks, drawing with your brush, massing in roofs, bridges and chimneys, free and bold.

A sheet of unprimed hardboard is a good base for a study of this sort, as it is very easily covered. There is the sun, making a descent, redder and redder. How quickly it goes, as you desperately work, trying to flick the lights against the orange-edged clouds! It is all happening too fast. Put in the sun, even though you can actually see it move: how difficult it is to get any of the tones and colors right; keep up your courage and take your time, even though you are working very quickly. Keep up the rhythm; don't panic. Suddenly down it goes; the sun is lost; the afterglow deepens on the water. Don't over-

work it – you've probably just about got it now . . . fine! Stop! Oddly, when you get it home, it will all be much brighter, as you will not have noticed that the available light has been diminishing all the while.

Rain and Storms

The same effect occurs, in a way, when working at a stormy sea subject – that is if you wear glasses, as when you work they are being obscured by spray, and again the picture comes up the stronger to you when they are cleaned. This is an invigorating subject. Go down to the beach on a very stormy afternoon or evening (or morning!) There are the great breakers before you, eight foot high, terrifying. Don't go too near or they will grab you and drag you into the undertow. The sea has a changing, unreliable temperament. But you can sit fairly close and

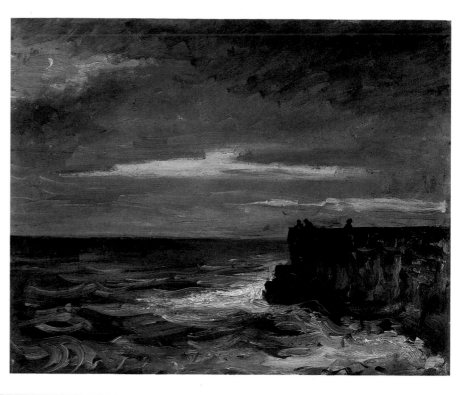

secutive greeny-yellow curl of the wavetops as they fall.

If you are still an enthusiast for all this outdoors all-weather on-the-spot stuff, then we have yet another area of activity: rain at night in a street. Dress yourself properly, of course, to prevent the water from getting to you. Rubber boots, jeans and a waterproof jacket that you do not mind getting wet, a good hat with a brim. The street should not perhaps be too much of a thoroughfare, or the passing traffic will splash you. Take your easel and work standing up for this. You will have to hold your palette box in one hand, unless you can rig up a shelf to clip to your easel. These excursions are best in spring or autumn, rather than the more freezing days of winter, although I have painted outdoors in snowy streets many a time. The danger is that you become so enrossed that you do not notice the onset of chilblains, and gloves are rather difficult to work in.

When painting in the rain, the reflections in the wet road and sidewalk of streetlights, stores and so on make a marvelous symphony of various effects that one can put in as strongly as possible. I first indicate the houses and stores with muted colors and then crash in heavily the white and yellow reflections with knife or brush, letting the light areas draw, as it were, what is around them. A friend sometimes stands for me in a suitable position for the composition, and otherwise I put people in as dark shapes and notes as they come along. A picture of this sort is definitely a painting of 'what happened when I went out to paint in the rain.' Its main virtue is atmosphere, but when framed and thus encapsulated, it is surprising what it can convey of such a scene.

work away in the fierce wind and rain, if you wish to ignore its buffeting. A firm cap or hat tied on well and a good zipped-up waterproof jacket or coat are essential. Weight your tin-box palette down with a nearby stone placed in it, having first squeezed out all the paint you are going to need in the shelter of a building or breakwater. Then out and face the elements! Again, dash in the blacks. You can stress the stormy sky all you wish, but again don't overdo the purply elements; there are green-gray parts as well in those clouds. Get the movement of everything, and study the shape of that huge breaker, as it hangs there before you for so long before crashing down, and the con-

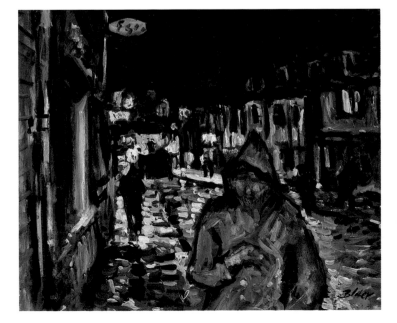

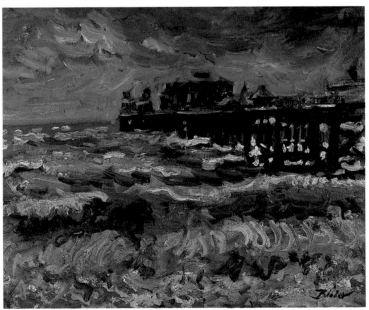

6. Compositions

In this section I shall discuss the painting of a large studio picture, a composition in which will be included a number of items such as people, animals, flowers, background and varying artifacts.

Firstly you will need a large canvas, and I would suggest stretching a cotton sheet on a 5×4-foot hardboard, as described earlier, and giving it a toning rub-over. Now is the time, if you are interested in painting from photos, to start collecting your material. Take an idea, a theme, possibly a religious scene or some more personal reinterpretation of such. It does not matter, except that it must *interest* you. You will then enjoy doing it, and you will learn much from carrying it out. Once you have painted a large composition, you will find that your smaller or single-motif pictures come very easily to your brush.

Having then decided on a composition for your theme, take your friends and, posing them in suitable positions, draw them, or photograph them (see page 46). Do both, for choice. Make separate drawings for hands and feet, because you will never get enough information otherwise. Draw or photograph other items, including your background

buildings or landscape. Do not make this last too involved, as figures portrayed in detail miles away give the wrong feeling to a picture. In real life you could not distinguish someone you knew from a stranger farther than about 200 or even 100 yards off.

Take your photographs, and have two sets enlarged as duplicates. Cut out the figures from one set so that you can juggle them about to find the most inspiring composition. This is a very interesting method that will generate a great enthusiasm in you for the subsequent painting of the picture. Once you have settled the arrangement, glue the figures down. You may then either work freely from your small reference collage, or square it up with a grid of squares, squaring-up your canvas with a grid of the

BELOW LEFT
Study of Hands

BELOW
Girl with Cat
Oil on board, 60×48 inches (154×123cm)
This subject is enjoyable for the contrast of personalities. It is best to paint the cat as soon as it has taken up a good pose, before it gets bored and moves. I have used the background shapes to give a sense of abstract patterning.

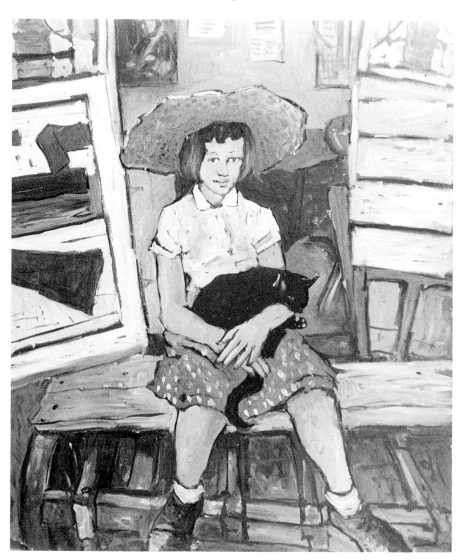

FAR LEFT
Story at Bedtime
Oil on board, 60×48 inches
(154×123cm)
A good subject, as both
figures are engrossed and
you can take your time with
the painting.

LEFT
Study of a Head

BELOW
The Bride
Oil on board, 42×48 inches
(107×123cm)
This large composition was
built up from a mixture of
photographs and drawings,
some made as studies like
the two on this page, to
create a semi-fantasy of a
bride leaving her home
town. The background is
based on one of my
evening river studies.

same number and proportion of squares. Working from the smaller to the larger, you can accurately transfer the main lines of your picture.

Square up your canvas by measuring the squares on all sides, and then taking a piece of string, dipping it in red or blue watercolor and, with a friend holding one end to mark one side of the canvas board and you the other, twang the paint-soaked string and it will leave a perfectly straight line. Work over the whole thing in this way, then number the squares to correspond with the ones on the collage.

You can now paint in your figures one by one, finishing as you go, which is better than hopping all over the place. Take your time and consider the whole composition all the while. And recall that the next one you attempt will be even better. It is not easy to make several figures fit together well and convincingly in a picture.

Do not over-paint items on afterward; they will show up as afterthoughts. Stick to your initial concept if you can. As you proceed with this kind of work you will probably become more free and direct, but it is as well the first time to work fairly painstakingly, drawing in the figures carefully in outline as you go. When you come to the background you will as usual be surprised how well it pulls everything together. The very proportions are altered by the tone behind a figure. You may leave spaces for the detailed painting-in of a bunch of flowers or something of that sort, which will be easier to deal with when the major areas of the group are complete.

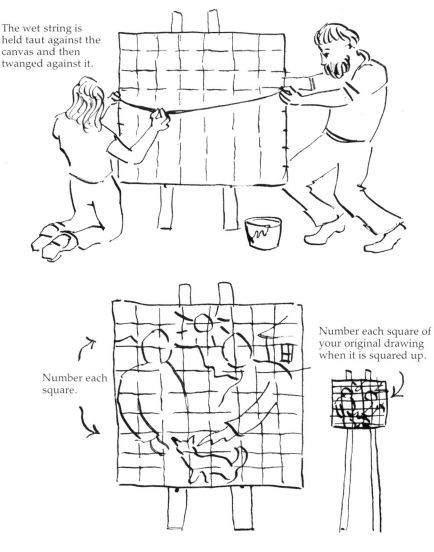

Squaring up a canvas with string dipped in water-based paint. Use red or blue paint and water it down.

The wet string is held taut against the canvas and then twanged against it.

Number each square.

Number each square of your original drawing when it is squared up.

Outline with brush, oil paint and white spirit, or charcoal, to be lined over and brushed away when the lining-in is dry.

Fill in the design of the picture, working from the small squares of your first design to the relevant squares on the large canvas. Make the design to the same proportions and measure up the same number of squares on each side on both your original and the large canvas.

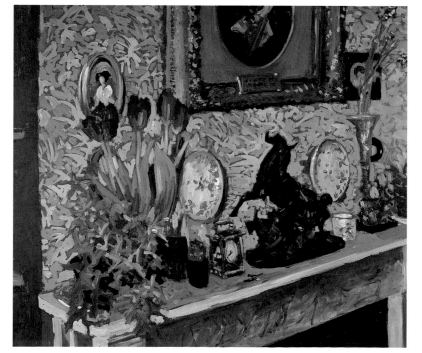

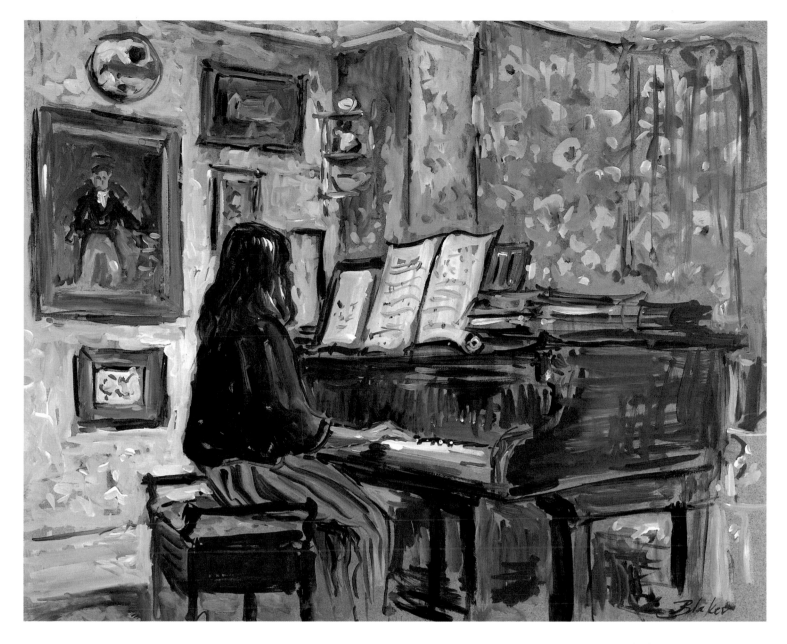

At times you may want to paint a large picture of a bright summery kind, at others you may prefer the heavily contrasted lighting of a Rembrandtian interior scene. It is all a question of tonal values; make certain you have got these sorted out in your preliminary collage. See also the advice given in the section on panel painting (page 60) regarding *glazes*. There is possibly a use for these here as well; though again, never overdo the purple and crimson or they will put everything else out.

Study large compositions in books and in the art galleries you visit, such as the ordered well-planned groups of Botticelli, Filippino Lippi, and Raphael himself in his early pictures – *not* the cartoons for tapestries, which are really rather dull. And not Michelangelo, as he is too wriggly and personal. Keep to those who paint stillness, even when they treat of movement.

Although you are painting a large composition, you are not painting precisely a mural, because a mural always to some extent implies decoration of a wall. It is not the thing to lose the wall and turn it into an illusion of reality; this is *trompe l'oeil*, a quite different concept, principally of virtuosity. Both murals and large paintings should reflect the fact that pictures are made up of telling shapes. The painting, unlike the mural, may be permitted the use of depth, and a certain suggestion that we are looking through a window into another world, but the picture plane must still be respected. Look at fifteenth-century tapestries and murals to see how the surface can be treated both decoratively and realistically, without becoming a mere carpet or a tableau of painted waxworks, with no feeling for art, placement of shapes and colors, or aesthetic balancing. You will find as you go on that you become aware of the need to repeat notes and shapes in order to echo and re-echo the harmonious construction of the composition.

7. Portraits

Panel Paintings and Glazes

We come now to a quite different approach using oil paint. The small panel paintings on wood by the Flemish artists of the fifteenth century, such as Van Eyck, Memling, Campin and others, are the ones you should look at. Here we have everything very finely detailed: a vision of the world that is supposed to be actuality itself, as much as a picture. Go to Bruges in Belgium, if you can, and look at the paintings in the galleries there – huge panels, but all treated as if each square inch was a little gem that you could hold in your hand. The panels work from a distance, of course, but they also work from very close up: a remarkable *tour de force* of an approach, because we usually proceed in a painting with some idea of its being seen from about three feet away. These Flemish artists expected you to go up and look from an inch away. The pictures therefore are truly miracles.

The panel painting is indeed a microcosm, that is the fun of it. It is not a miniature; there

is a difference. A miniature is very small. It can be on a button, and is to be looked at as if at a watch pulled from a pocket. With the panel, as we have said, it must read from across the room as clearly as from close up. You need great practice and expertise here in order to achieve these qualities, but the sooner you begin the better! The essence of this form is the portrait, and these pictures were painted from very careful pencil portrait drawings, made in silverpoint in those days. This was a sliver of silver in a holder, used on a sheet of paper covered with a wash of Chinese White watercolor. An advantage of this tool was that presumably it needed little sharpening.

We shall need then, first, to make a drawing of the person we wish to portray here. A photograph, even the best and most inspiring, will not do because you have got to be very exact indeed, and the closer you look at a photo the more blurry it becomes. The early painters were not averse to all the help that they could get, of course. They rigged

FAR LEFT
Girl with Blonde Hair
Oil on board, 20×16 inches
(51×41cm)
The very light hair and the suntanned face of this sitter make an unusual contrast. This is a direct and forthright study, concentrating on the immediacy of the approach.

LEFT
Studies of Heads

Building up a portrait panel painting with glazes
ABOVE RIGHT
Draw in the head with pen and ink and add light Raw Umber.
ABOVE FAR RIGHT
Add a light glaze of transparent Golden Ocher and white lights to the face, pink the lips, add some further modeling with umber.
RIGHT
Put in the sweater with umber and black, stippled with tissue. Draw in the background and begin painting in with blue-black and green. You could use either Terre Verte or Sap Green here; both are useful for glazing.
FAR RIGHT
Glaze the hair again and add more umber. Paint in the background, glaze it at least once with Golden Ocher. Add more light to the face and glaze yet again.

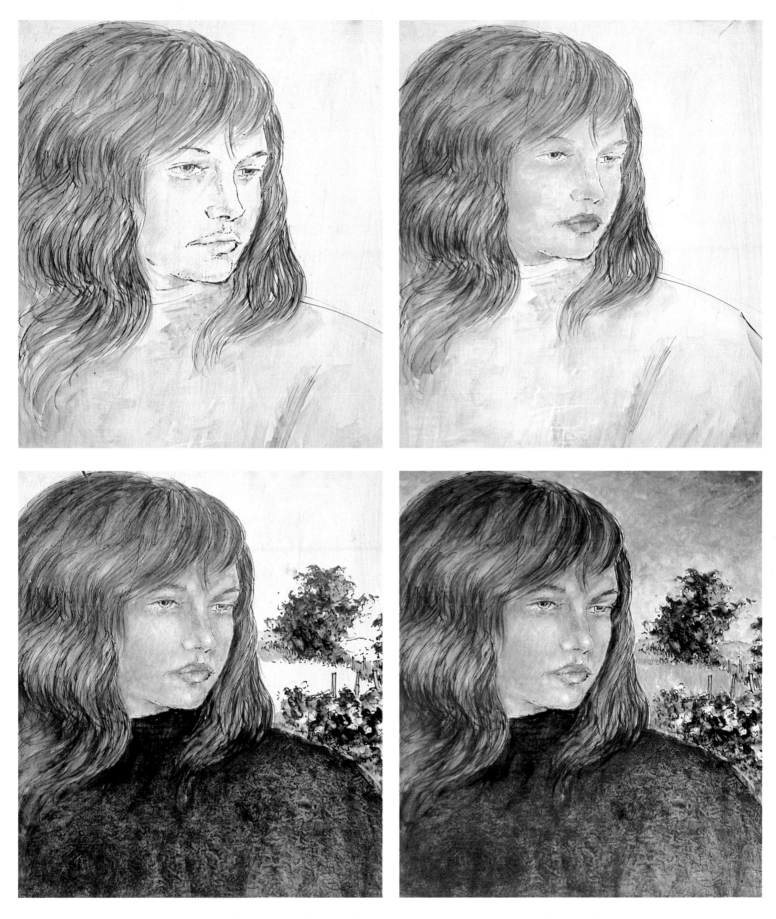

up a spyhole for the eye, with a flat piece of glass on a holder set a few feet in front, and with eye fixed they traced the outline of their sitter upon the glass, presumably with a brush or some sort of pen or pencil. They then transferred this image to a sheet of paper using a pantograph, which holds a pencil at one end and a steel point at the other. You follow your drawing with the point, and the pencil draws the corresponding image on a sheet of paper, varying the dimensions according to how you set the equipment. Holbein apparently used these instruments for his portrait drawings,

although, rather as with working from photographs, the only artist who is able to gain much help from them is the one who really doesn't need to anyway.

Once indicated on the panel, the portrait is lined in with pen and ink. Pen and ink and oil may sound an odd combination but for this approach it is very useful, allowing an immediate and controled detail. But before we get to this stage, it is perhaps best to prepare our support. As we do not have very handy today a prepared oak panel, cradled and braced at the back against possible cracking over the centuries, I would recommend chipboard, on which a thin layer of hardboard has been veneered on both sides.

LEFT
Study of a Head

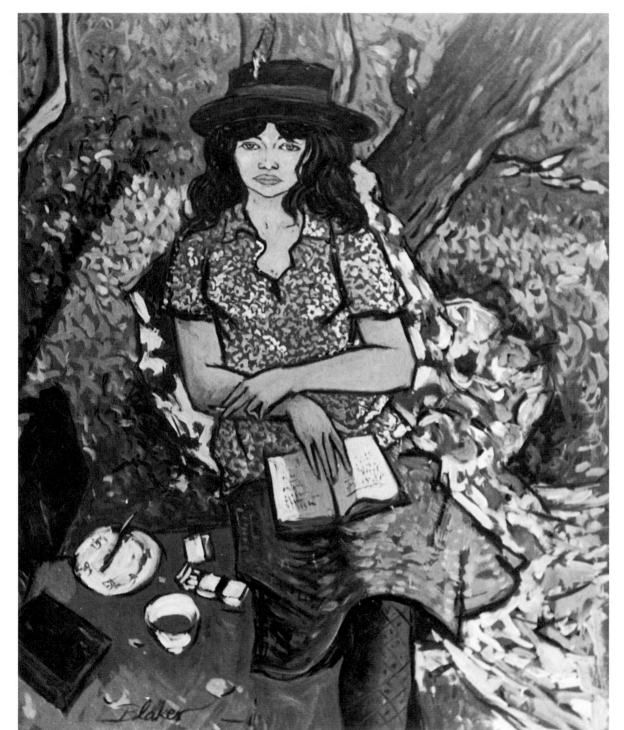

LEFT
Tea in the Garden
Oil on board, 60×48 inches (154×123cm)
When painting these large outdoor pictures on the spot, I try not only to give a portrait of the sitter and the afternoon, but also to stress the decorative, abstract quality of the scene before me. The sitter's features are only part of the whole, there are also textures – the pattern of the dress, the blouse, the cushions – and items such as cigarette packets and teacups, grass and leaves, all building up into a pleasurably harmonious tapestry.

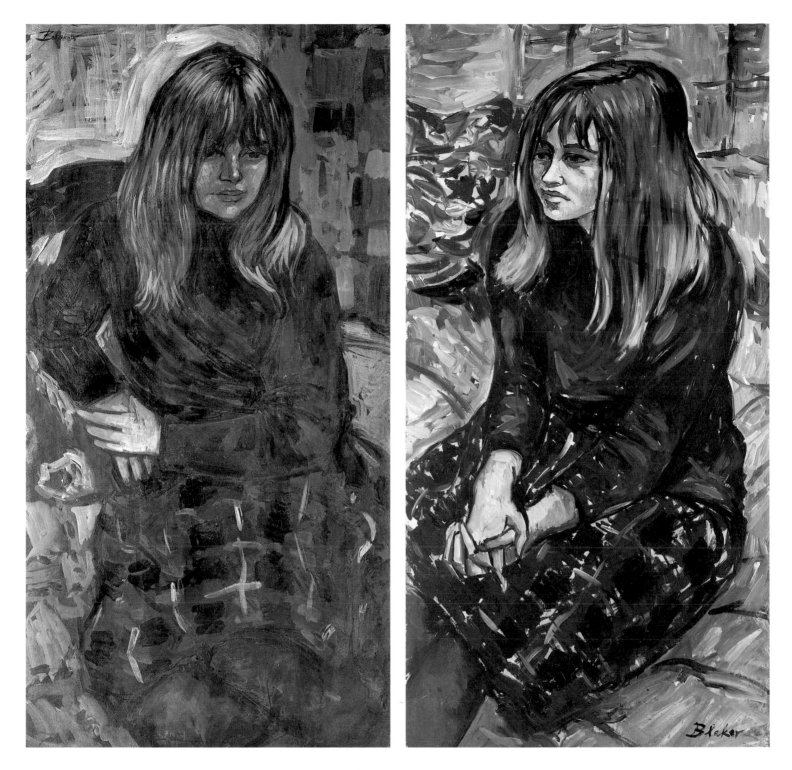

If you look in the offcuts boxes of do-it-your-self stores, you may find small, or even fairly large, panels of this sort, about half-an-inch thick and perfectly smooth. Do not buy the chipboard covered with a vinyl or plastic veneer as this has no tooth on it, not being made of natural products, which are always slightly impure under a microscope, and so will not hold the ground.

Taking your hardboard-covered chip-board, now paint a layer of white undercoat over it. Let it dry overnight, and lay another, and so on until you have a good ground with some four or so layers. Do not apply it too thickly; thick paint cracks, thin layers do not. The secret of Chinese lacquer, for

example, is an endless number of very finely applied layers, rubbed down and applied again. Next, rub some pale green paint and paint thinner slightly over the surface – just a little, to tone it; the white is too bright for convenient working. Mix the green from your umber and yellow. When it is dry, take your pen and sepia or Indian ink (and make sure that it is waterproof, not non-water-proof, as there are two varieties, and the first is stronger) and copy your pen study on to the panel. You will have to work by eye, un-less of course you can master the panto-graph, or you could experiment for yourself – maybe you could carbon it on and then line it in afterward. Think about it. Now is the

ABOVE
Val 1
Oil on board, 48×24 inches (123×61.5cm)
This portrait was painted on a white ground, with a good deal of flourish. The sitter has a good face to paint, both attractive and with good bone structure, and the painting went well.

ABOVE LEFT
Val 2
Oil on board, 48×24 inches (123×61.5)
This picture has a darker, more tonal effect, painted thinly and worked up with a fairly detailed treatment of the face.

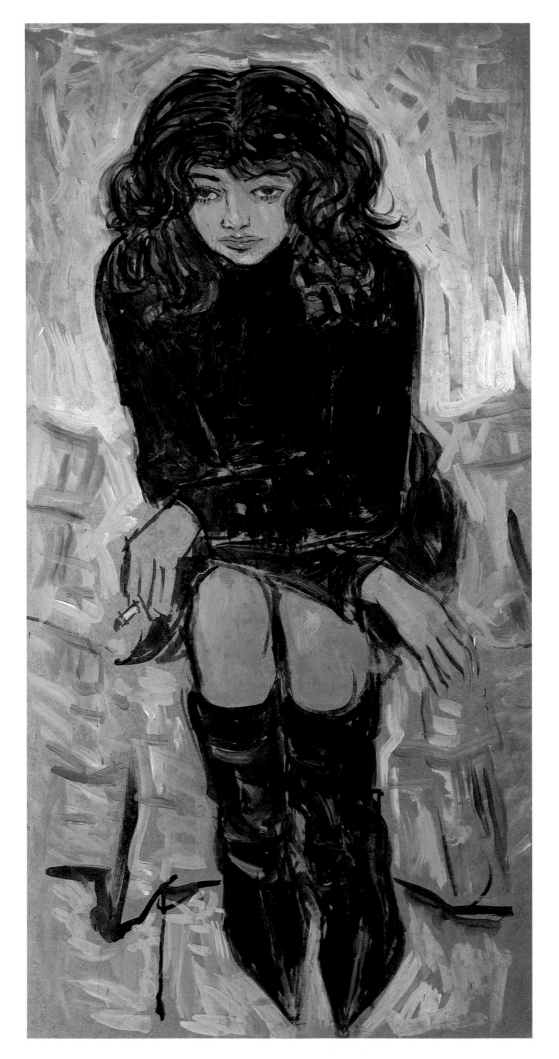

LEFT
Girl in Boots
Oil on board, 48×24 inches
(123×61.5cm)
This is a quick, thinly
painted full-length sketch;
the pose could not be
sustained for long. While
the comfort of the sitter is
obviously a consideration,
you should only ever use a
pose that you feel *must* be
painted, or you will not
produce a work of art.

RIGHT
Nicki in an Overcoat
Oil on board, 60×48 inches
(154×123cm)
This was painted in a cold
studio on a wintry evening
under the greeny glow of
gaslight, which gives a
certain drama. I have used
a Modigliani-like simplicity
of line and construction to
get down something of the
force of the strongly
illuminated image.

time when, as an artist, you will begin to have ideas and inspirations about these technical art procedures, as you develop your abilities. Every artist has little tricks and ways that he has thought of, and this is all to the good.

We now have a careful pen drawing on our panel. Incidentally, you would do well to have coated the side and back with black decorator's undercoat followed by black gloss. This will seal the panel against water or damage, as chipboard is absorbent and water will swell it. It is easier to protect and seal it up before the painting of the picture commences. You will now need Raw Umber and mineral/white spirit. With a fine sable brush, start shading in the tones of the face in order to make it solid. You will have indicated something of this on your drawing from life, which should have been made so as to give you the greatest possible amount of accurate information to work from, rather than being a masterpiece in its own right, although, probably because of this approach, it is more likely to be so! You can be fairly bold with this, as it will be toned down in contrast by the succeeding layers. With each layer, increase slightly the proportion of linseed oil and varnish in your medium of turpentine or mineral/white spirit. For myself, I prefer the spirit almost throughout, but some find it too thin. Turpentine I find slightly too gummy and quick-drying but, as with all media, you will find what suits you best. Remember always to have some soft toilet paper handy, to dab off errors or to rub off a too strongly colored

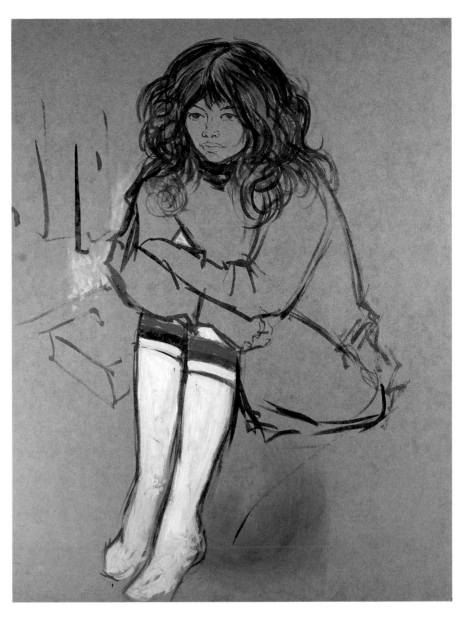

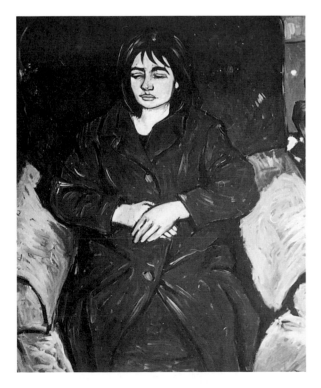

glaze; you may even model with it to some extent. Of course every coat must be applied over a perfectly dry previous coat.

Leave your umber-shadowed panel for a day to dry, and the next day add some more modeling in the shadows with a slightly darker mixture, keeping it thin all the while, without much body to it. As there is a good deal of waiting-to-dry time involved in this craft, it is a good idea to have several panels going at the same time. As you proceed you may want to have a composition of say, several heads, with hands holding flowers, perhaps (a favorite with your models). Now work on some modeling to the hair, which you will have drawn in rather carefully with your pen. There is no demand for speed with this art, in fact the opposite. This is a studio art, not an on-the-spot recording of, or response to, life in the raw before you. Here, in the studio, you can create, you can people your room with new worlds.

The next stage is to paint a little color into the face. We are going to use some thin

ABOVE
Girl with White Socks
Oil on board, 48×36 inches (123×92cm)
The figure is drawn in on the board and ready to paint, giving an idea of how to draw speedily. I do not usually make such a complete image in brushwork but I wanted to focus on the socks as the dominant feature. Having done so, there seemed no reason to do more.

white undercoat as well as the tints here, and begin by putting in some lighter tones, still using a little umber for shading, and some Alizarin Crimson for pinking the whites. Rely a great deal on the modeling that you have already painted underneath. Paint thinly, letting the modeling come through; you will find it of great help to you. Paint in the lips with a pinker mixture, the whites of the eyes and the color of the pupils. Do not lose your line. The hair, if golden, may be colored with a transparent glaze of mineral/white spirit and some Transparent Golden Ocher (a very strong pigment best used thinned).

You may now begin to add a very little of your oil and turpentine medium to the mineral/white spirit to give the succeeding coats a little more strength. You do not want them shiny, however, so be careful. After drying, work on the face again with another glaze of Golden Ocher plus umber and crimson as required, and perhaps some Terre Vert, a tube of which will be useful. Again, work up your lights with white, so that the light will come through at the next glazing. Eventually, adding as many coats as you want, you will evolve a surprisingly strong and solid modeling. The dress may be treated the same way, or painted more directly in one coat, if you wish, though shadowed folds painted first and then color-glazed, with highlights added and glazed again, give the best effect. Patterns may be added when dry, and glazed with gray or umber for shadowed areas. Flowers can be painted in the same way. The background can come from drawings or paintings. Glaze a golden glow on it afterward if you like.

Never rub out or remove a layer. Do not be in a hurry to have a finished picture. Apply your glazes with care, work into them, and always let them dry well before a further application; impatience has no place here. Finally, a coat of varnish, and you hang the panel on the wall. Of course, you can use your usual solid color in combination with the glazes, as you wish, but work out first what you are going to do, and remember that the whole point is for layers to show through from beneath. Never work over a surface unless it is matt, that is, does not shine.

Painting a Self-Portrait

It is always a good idea to paint a portrait of someone who will not take offence, whose criticism you do not fear, and who will not

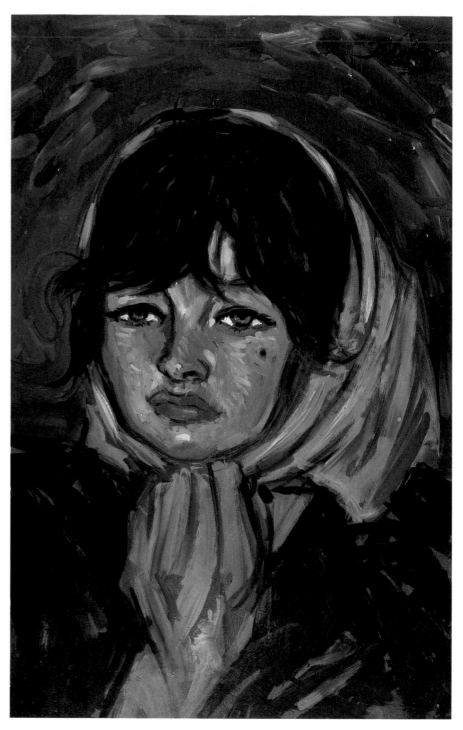

object if you over-emphasize the character of the subject – in fact, yourself! For practice in the painting of the human face, you have an ever-present model with you; all you need is a mirror. There are few among the celebrated painters who have not left us one or more images of themselves. Of course the most famed must be Van Gogh, whose own reflection seemed to dominate him to an autobiographical extent; and then there is Rembrandt, almost as obsessed, from youth to age. It is not just egoism or an undue interest in oneself that prompts self-portraiture. There are often ideas you want to try out, effects of lighting or tone, of color or angle; and you are always there, ready at a moment's notice.

ABOVE
Girl in a Headscarf
Oil on board, 48×36 inches (123×92cm)
This is a quick study of a sitter I have painted many times, and I was able to concentrate on tone, color and liveliness, all essential to a portrait.

RIGHT
Spats Drawing
Oil on board, 48×36 inches (123×92cm)
This picture, with its atmosphere of intensity, the concentrated down-turned face, the emphatic arms, makes its point with a certain amount of action, emphasized by the lighting and conveying perhaps the dignity of labor.

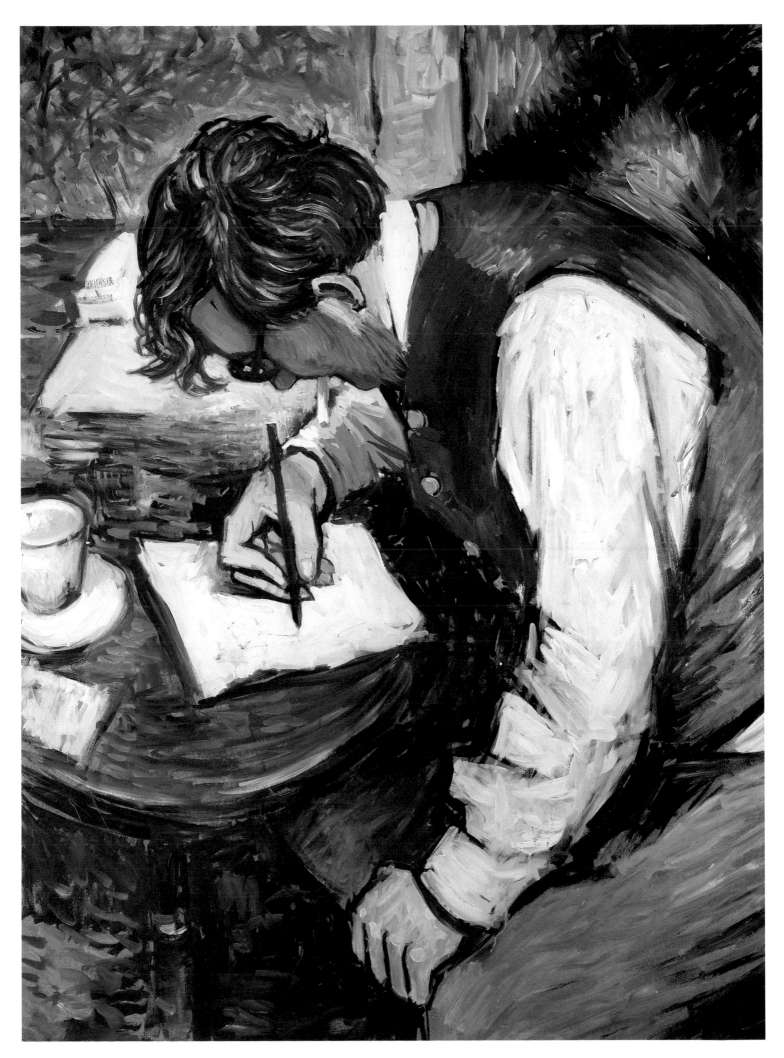

Choose your lighting well, and your position. Again it is best to paint standing, as the sitting position tends to slump the figure and give the effect of a strained neck or an over-upward look to the eyes. The three-quarter view is a particularly suitable one. You may also arrange two mirrors in order to get a view of yourself from behind, or a three-quarters or even a disconcerting profile view of someone who does not appear to know they are being watched! Lamps are useful, as well. A table lamp situated below your face will throw up unfamiliar shadows and lights, so that you perceive human form without those conventionally placed shadows below eyes, nose and lower lip that we have come somehow to suppose are a norm of appearance because we are usually depicted so.

I painted at one time, through a long night of quietness, a large 5×4-foot self-portrait, using a palette knife and a vast quantity of expensive paint, showing my reflection in the window, with the night outside. This was in a shack in the heart of the country and there was no light outside to destroy the image, which was toned down very subtly by the darkness beyond. At other times I have spent a whole day painting my head reflected through different positions of the mirror – direct and free oil sketches on bare

hardboard. Then you can vary the shirts you are wearing, and collect a variety of hats, which are great fun and quite alter the proportions of the head as seen against the background.

A self-portrait with an animal is another idea. I painted a life-size 6×4 foot hardboard of myself in the park carrying my small white dog Hero, with Sweep, the black labrador, on the lead. This was painted in the studio using a full-length mirror. Sweep was put in from life, not the mirror. The background I expanded in the same style from a 20×24 inch landscape painting I had made in the park, and Hero was painted from the reflection in the mirror of him in the crook of my left arm, although of course it comes out as the right in the painting. My left hand was put in from life. All this takes a bit of organizing. I have another self-portrait simply holding Hero, and this of course gives the appearance that I am painting left-handed.

I have tried very detailed self-portraits, and have also used the interesting image of a self-portrait with cigar or pipe. Here we have the opportunity of painting with swift

ABOVE
Self-Portrait in a Window at Night
Oil on board, 60×48 inches (154×123cm)
The drama of this pose was suggested by the low tones of my reflection, seen in the window after sunset. I spent most of a long night at this picture; the effect of the darkness and the gaslight created a Courbet-like solidity. The whole head, and most of the rest of the picture except the background, was painted with a palette knife. This was a chance to use strikingly Rembrandtian contrasts; you could try using various effects of lighting from table lamps to give other dramatic effects.

LEFT
Self-Portrait in the Park with Dogs
Oil on board, 72×48 inches (184×123cm)
This was again painted in a mirror, on a very large panel of board. The background was taken from an earlier study made on the spot.

directness, smoke clouds issuing from the pipe, cigar or cigarette, with the bright red glow of the burning end making a valuable note. For the finest image in this genre, look at Manet's *Le Bon Bock*. A book of self-portrayals by the most appreciated painters could give you ideas and suggestions for positions and variations. A background of plain gray suits some images, while at the other extreme a large landscape, town or relevant building may be included. Alternatively a partner or friend can share the given space. At one time the Uffizi Gallery in Florence had a famous collection of Victorian self-portraits by the most highly respected international artists of the day, and it was considered the final accolade if you were asked for one – you had hit the big

BELOW
Edouard Manet
Le Bon Bock, 1873
Oil on canvas, 37¼×32¾ inches (95.4×83.8cm)
This work was criticized in Manet's lifetime as being different from his other paintings; the characterization is firm, the handling free, the smoke put in with directness.

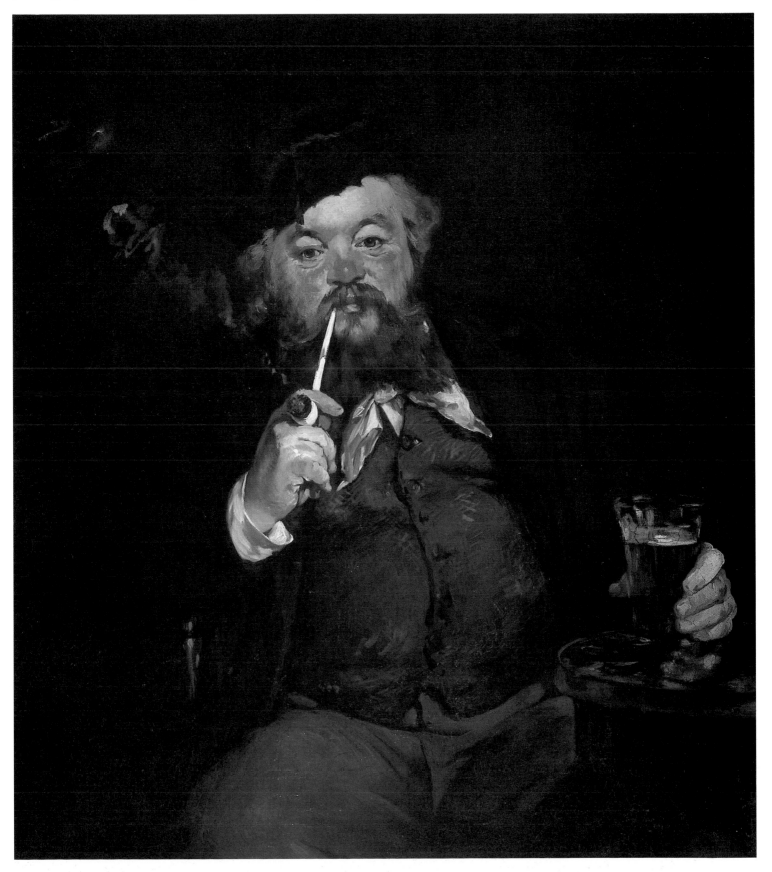

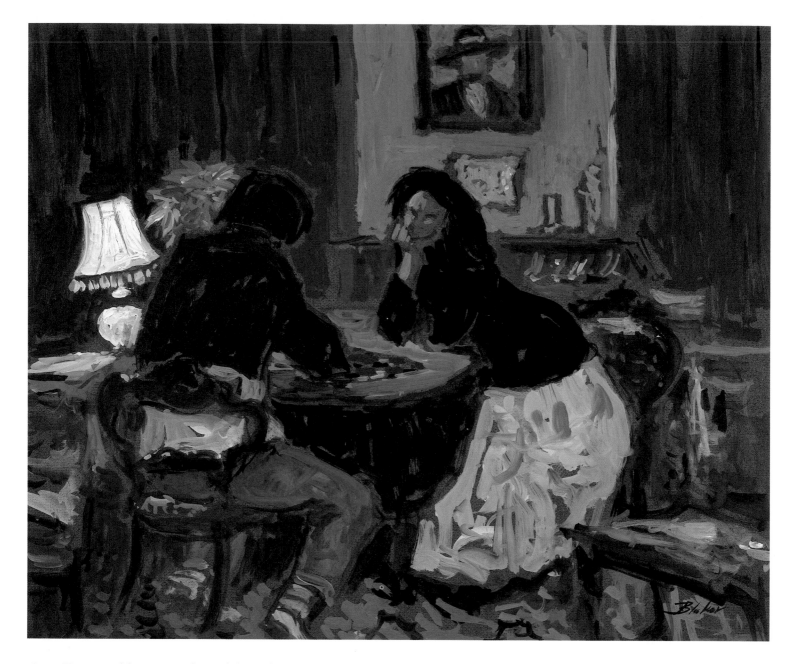

The Single Figure: Portraits

The Chess Game
Oil on board, 20×24 inches
(51×61.5cm)
I came upon this subject as
I walked into the room, and
went at once for my paints.
Casually adopted attitudes
such as these are a gift to
the artist. The light makes
an interesting contribution,
and has been emphasized
by the use of the palette
knife.

time. Regrettably quite a few of these heroes
were seen by later generations as not quite
the titans they appeared to their contempor-
aries, but their time may come again. Think
of Alma-Tadema, up with the highest once
more after a fall that might have paralyzed
any reputation.

 The interior of one's house or room is a
good background for a self-portrait; in fact
the painting of a room is another pleasure in
store for you, not least for the painting-in of
the various pictures hung on the walls. To
reduce these familiar items to a telling im-
pression with a few brushstrokes in the right
place is an exercise that should be
attempted. The tones of the walls, in
contrast to the light from and through the
windows, are another point from which
there is much to be learnt. The inclusion of
figures, not as portraits, but as equal items
with the furniture and fittings, should also
be tried.

We now come to what is perhaps the most
exacting of all subjects: the single figure in a
painting. Here we have no other character
for him to bounce off: he must exist con-
vincingly alone, on his own merits. We
therefore have to give this figure a psycho-
logical empathy with himself, a convincing
identity, a persona, that will interest and
absorb the onlooker, any onlooker, for a
long time; an enigma that intrigues all, gives
little away, and remains a perennial attrac-
tion. Quite a commission, that! But if you
bear these points in mind, your portrait,
nude, or single figure may have something
about it that just captures a hint of what we
are after here. Do not paint a figure, at all
events, as if it were merely a jug, a wooden
box, or a dummy. It is a person, and we

Spats Thomson
Oil on board, 48×36 inches
(123×92cm)
Here by contrast the sitter
is consciously posing for a
formal portrait. He is
dressed in dignified
fashion, sporting a
monocle. With a
commissioned portrait, the
artist is perhaps less free to
please herself, but this is a
valuable sphere of work.

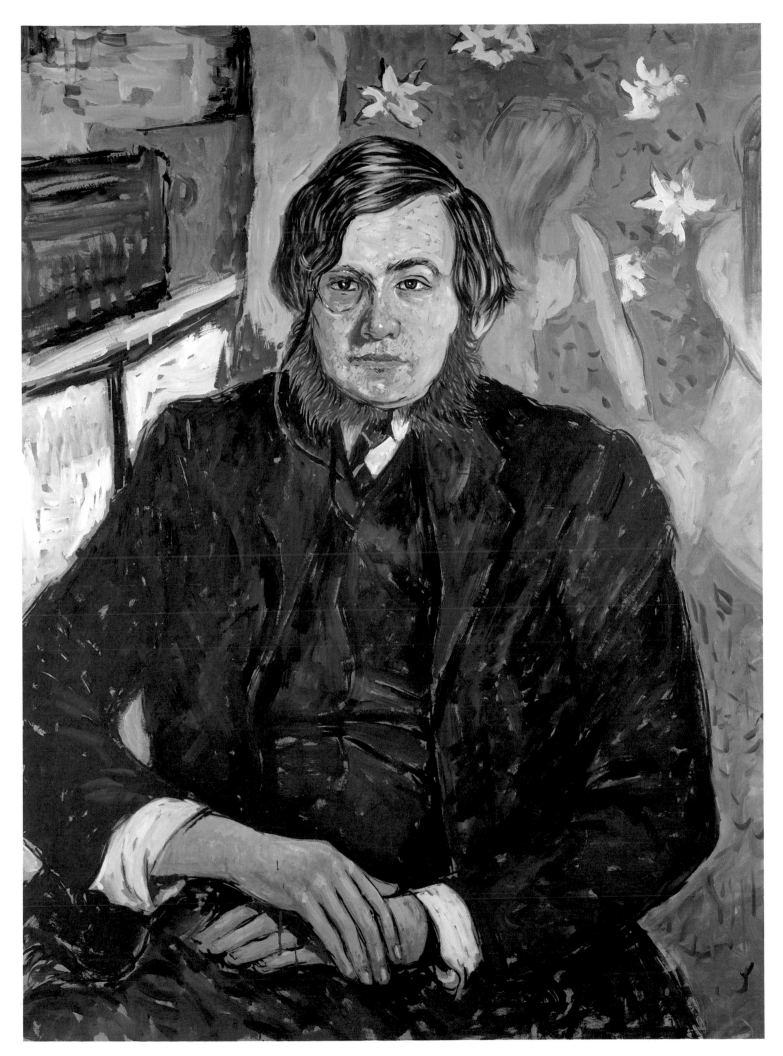

should take the humanistic view in art, of Man as the center of nature, Man as the measure of all things, the shining example for all creatures, whereas fashion, at times, has a way of considering man (yet still ourselves!) as some guilty creature responsible for the world's ills.

Man, as you can see by looking at most of the great masters' work, is a subject of endless fascination for artists, and particularly the portrayal of the individual. Painting is not just a matter of Cézanne's quest for

form. As a recluse and something of a misanthrope, that artist required his own dedicated, narrow approach. It is not that of all of us, however, and I think the Lautrecian variety of character and individuals of interest in the world gives us a panorama of figures, even in an everyday walk down the road, some of whom should and must be painted.

I have told you many things about the act and methods of painting in this book. It is now time to find what you want to paint. I

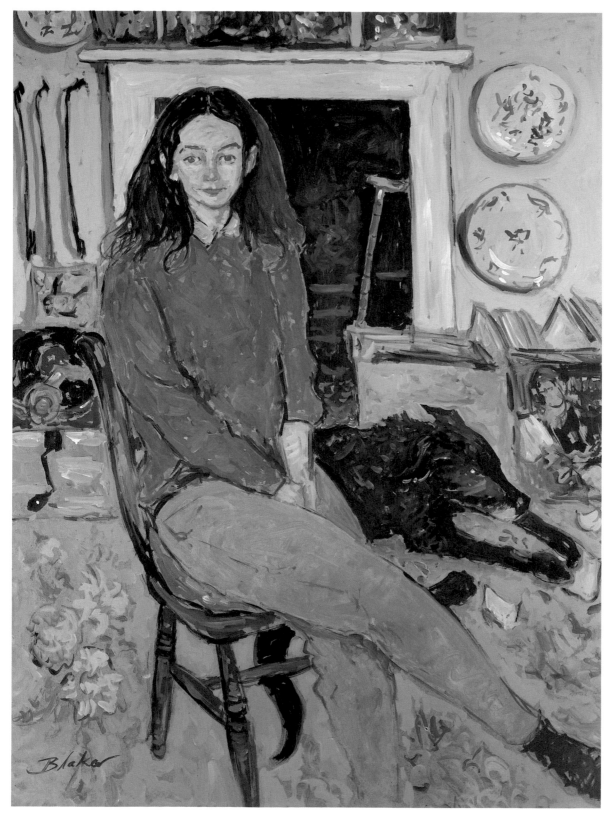

Blaker

LEFT
Girl in Blue
Oil on board, 48×36 inches (123×92cm)
This portrait includes a number of objects in the background, such as the mantelpiece and the phonograph, the shapes of which relate to the main figure.

RIGHT ABOVE
Turkish Girl
Oil on board, 48×24 inches (123×61.5cm)
This interesting sitter seemed to require a restrained palette of black, white and ocher to render her olive skin and the dramatic black and white dress she is wearing. The glasses have not been treated with too much emphasis; it is easy to fall into the trap of making them seem more obvious than they are.

FAR RIGHT ABOVE
Jean in Red
Oil on board, 48×24 inches (123×61.5cm)
Here the dramatic contrast of hair and skin tone is made all the more striking by the red dress.

NEAR RIGHT BELOW
The Recorder Player
Oil on board, 24×16 inches (61.5×41cm)
This was painted unposed, as the fingers were in movement; a good exercise for the artist.

CENTER RIGHT BELOW
Rod with Sousaphone
Oil on board, 48×36 inches (123×92cm)
A fast, direct study painted in line and mainly in two tones. The shape and complexity of the instrument is a bonus.

FAR RIGHT BELOW
The Trumpet Player
Oil on board, 48×60 inches (123×154cm)
This larger-than-life study was made on a textured white background which did not seem to need further finishing. The incentive here was the fun of painting the brass instrument and conveying the sense of jazz being produced, attacking the subject with vigor and directness.

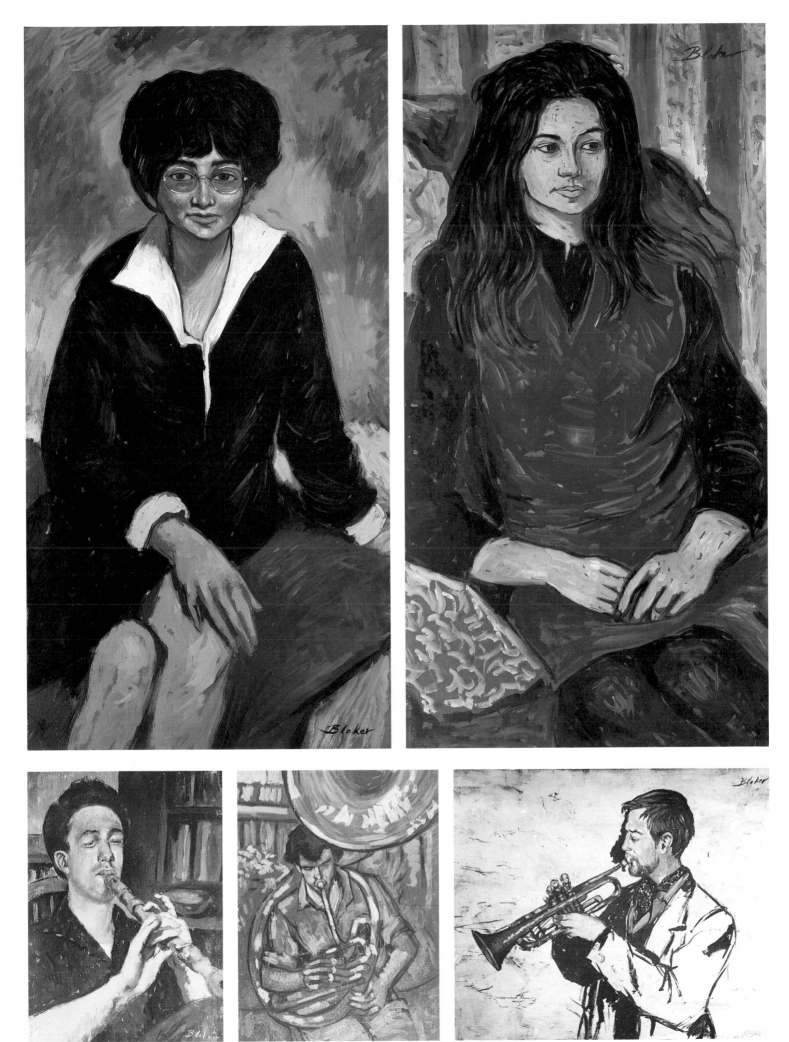

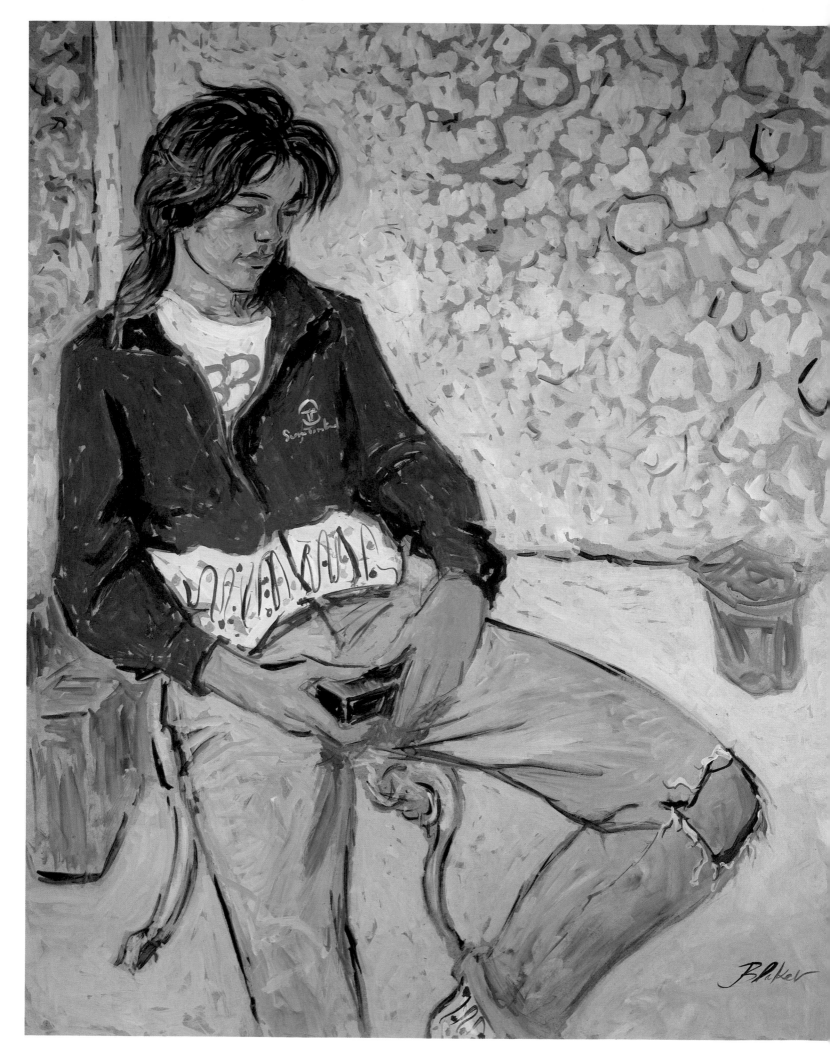

LEFT
Matthew Listening to Radio
Oil on board, 60×48 inches
(154×123cm)
The sitter is absorbed in
music and is therefore
completely relaxed.

RIGHT
Denis Playing Banjo
Oil on board, 60×48 inches
(154×123cm)
While I painted the banjo,
the sitter moved a bit and
the instrument appears to
be twisted.

BELOW
At the Piano
Oil on board, 20×24 inches
(51×61.5cm)
The subject is lit by a
standard lamp, which
concentrates the light. The
white music and keys
reflect most light back,
while below the seat and
the piano are contrasting
deep shadows.

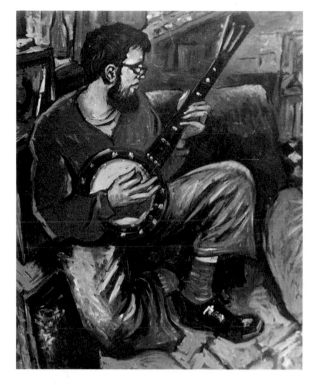

have also tried to suggest many ideas and subjects. This final one, the isolated individual, may be treated by you as you please. Make them a god, make them a modern messiah bearing the guilt of mankind or whatever, but don't make them without interest. Never paint for the sake of merely painting something. If you have no inspiration, leave it alone. Find a new subject or place or creature. You will soon find something that wakes the tired brush.

There are musicians, for example. Get someone you know who plays an instrument to let you paint them while they practice. No desultory sketchbook pencilings that you apologetically show and promise something better perhaps another time. Go the whole hog. Get a good sheet of hardboard on your easel and get on with something full-bodied. You will not have to worry, as one does when painting a friend

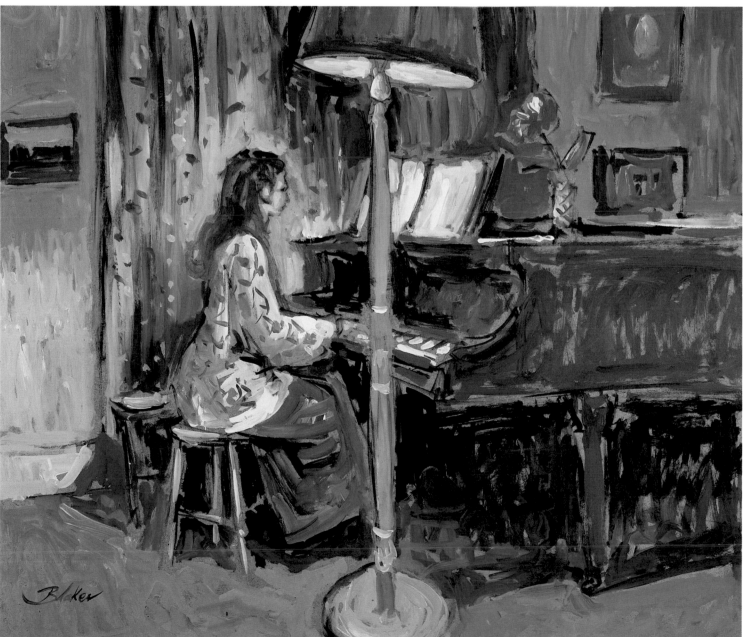

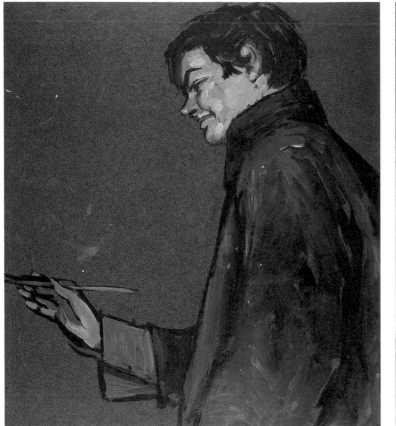

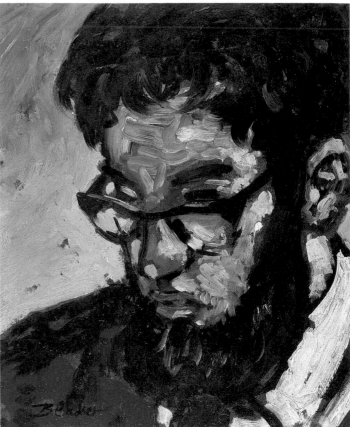

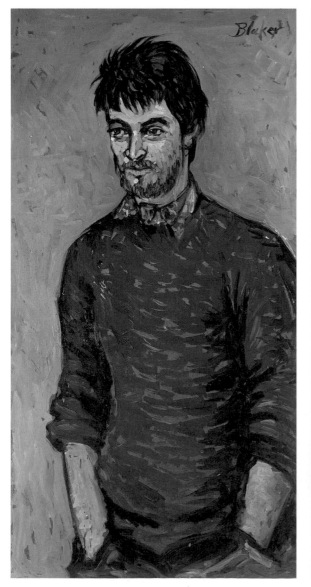

ABOVE LEFT
Rod Painting
Oil on board, 24×20 inches
(61.5×51cm)
This study of a fellow-artist
working is painted directly,
with simple planes and
lines and a limited color
range of black, ocher and
red. The background is bare
board; the brown of the
board makes a satisfactory
foil to the tones of the
head.

ABOVE
Denis
Oil on board, 10×8 inches
(25.6×20cm)
This small study of a head
is made in broad direct
strokes and patches, almost
like a still life.

FAR LEFT
John
Oil on board, 48×24 inches
(123×61.5cm)
This standing portrait
shows extensive use of line
and an unposed, informal
treatment of the subject.

LEFT
Jean-Auguste Ingres
La Source, 1856
Oil on canvas, 64×32
inches (164×82cm)
This is a beautifully drawn
and subtly colored
painting, taken to a high
finish that could be equaled
by few artists today.

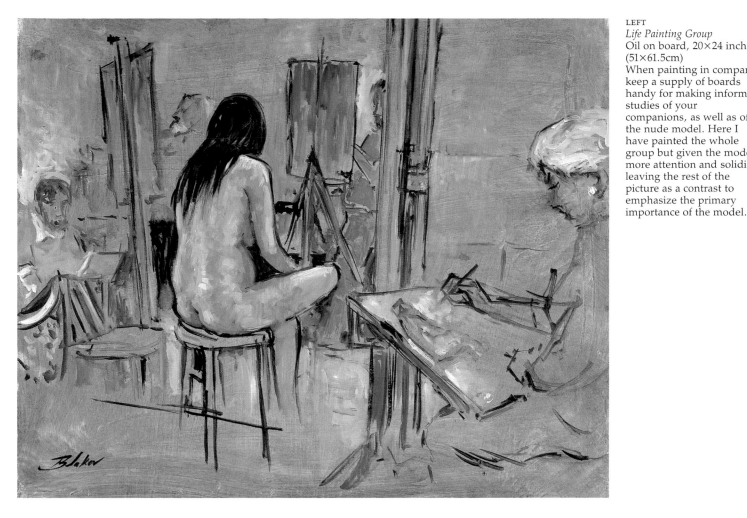

LEFT
Life Painting Group
Oil on board, 20×24 inches (51×61.5cm)
When painting in company, keep a supply of boards handy for making informal studies of your companions, as well as of the nude model. Here I have painted the whole group but given the model more attention and solidity, leaving the rest of the picture as a contrast to emphasize the primary importance of the model.

simply sitting there, that you are perhaps boring them or wasting their time; your musician can play and you can paint, and so the day goes profitably by for both of you.

The Single Figure: Nudes

Painting the nude is a subject that all good painters have attempted. You will really need a model to yourself. If you paint in a life class or group, you cannot usually get near enough as there are so many of you at work. Take care in posing your model. You need not hurry, though you must give them rests! This is a most absorbing subject; and here again we have the luminous flower-petal element, the fact that shadows in flesh are never very dark, but all have an inner light. It is not a dead material. Keep your black pocket comb handy to check the depth of tones. Contrast the areas of hair with the flesh, and contrast items of dark tone in the background to bring out the luminosity of the figure.

Take every opportunity to visit museums and galleries and look critically at everything that you find. There are also many good-quality and reasonably priced art books available which will repay study. Look at the modeling of the bust in Manet's *Olympia*;

look at Modigliani nudes and their glowing quality. Look at Ingres' *Grande Baigneuse*, and his *La Source* in the Musée d'Orsay, pictures only just brought out once again from cellar obscurity. How luminous are those grays! Gray flesh, but living. Look at Salon painters, academics. Look at Thomas Couture, the man who taught Manet, and his *The Romans of the Decadence*, that huge picture now restored to light. Bits could be by Manet, perhaps were; look at the flowers on the floor in the foreground – pure Manet! Look at Salon traditionalists, not at

BELOW
Jenny Nude with Cat
Oil on board, 36×60 inches (92×154cm)
This also has a monumental and sculptural quality, and the scale of the image is intensified by the way the limbs have been cropped, suggesting a still larger panel. The addition of an animal reflecting the mood of the sitter can be effective.

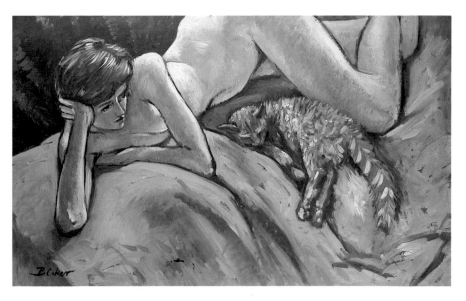

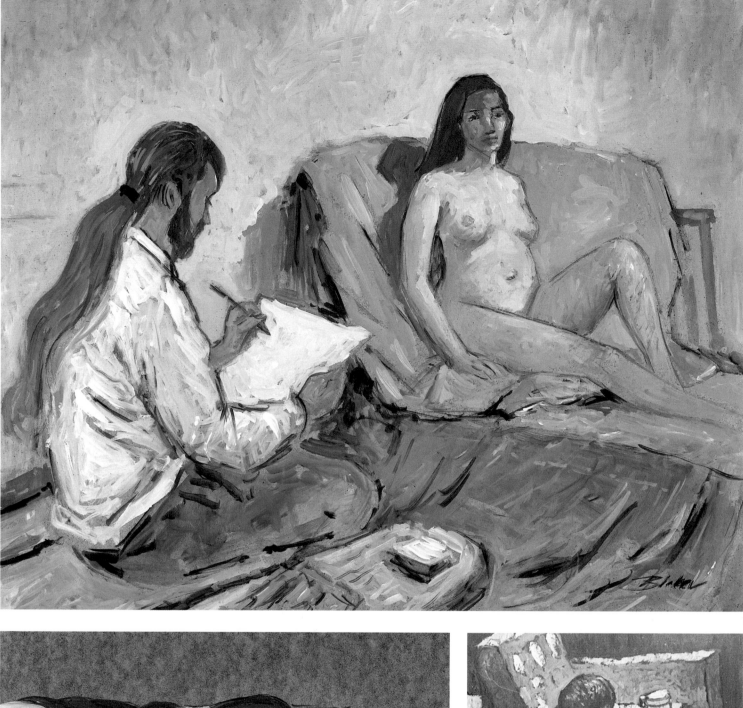

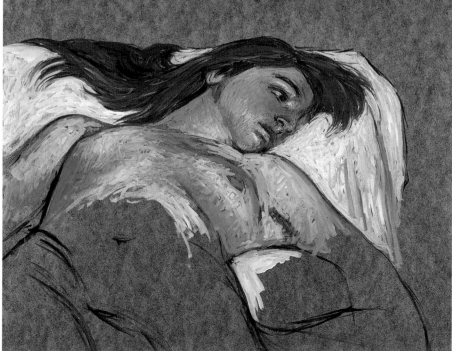

LEFT
Artist and Model
Oil on board, 20×24 inches
(51×61.5cm)
Painted in a life group
session, this pleasant
vignette of two people
suggests a sense of repose
and rapport. It is important
with this type of subject to
avoid both the sensational
and the sentimental, and to
be purely objective.
Painting from life is an
excellent way to learn how
the limbs and muscles
arrange themselves in
different positions.

FAR LEFT
*Study of a Nude with Red
Hair*
Oil on board, 16×24 inches
(46×61.5cm)
This has been left half-
finished, because the
session ended and I
preferred to leave it as it
was, rather than working
on it again in a later life
session.

LEFT
The Bath
Oil on board, 60×48 inches
(154×123cm)
This is another life-sized
picture. The water in the tin
bath reflects not only the
gaslight above, but also the
red glow from the stove
just out of sight, which also
reflects off the bather's
chest. The result is a unique
interplay of light effects.

RIGHT
Seated Nude in a Life Session
Oil on board, 24×20 inches
(61.5×51cm)
The pale green ground on
this panel shows through,
giving a warmth to this
picture. The patterning of
the old mattress provides a
useful bit of abstract design
to contrast with the broader
areas. The black mass of
hair falling forward makes a
dramatic shape against the
light background, and the
planes of the figure are
brushed in boldly with
three main tones: a grayish
shadow color, a pinkish-
yellow local main color, and
white worked in for the
salient points that catch the
light. The whole subject is
treated very broadly, with
no attempt at detail.

moderns. Don't learn from Matisse. Matisse is for sophisticated connoisseurs, not for beginners to learn from. He is Matisse; it is no use you trying to be him as well. Learn from the modest, not the innovators: it is the modest that taught them all they know. As a wit once said, a converted Pre-Raphaelite makes the best artist, while according to Ruskin, there is no known example of a great painter working freely and broadly in maturity who did not in his youth work with detailed care.

A final word: study the way a great master signs his work. Sickert said there is one place, and one place only, in every picture for the signature, and it is always a different place. Make it part of the design, as does Van Gogh, following the practice of Japanese woodcut artists. Never place it at an angle across a corner. This is a common fault and at once stamps the picture as the product of someone who Does Not Know. Your aim should be to elevate yourself into an artist of ability and knowledge, whose work will be entitled to respect. So now, go to your painting with conviction and confidence, and remember above all, don't fudge, don't try to be too clever, and don't be too impatient. Good luck, and keep your brushes washed.

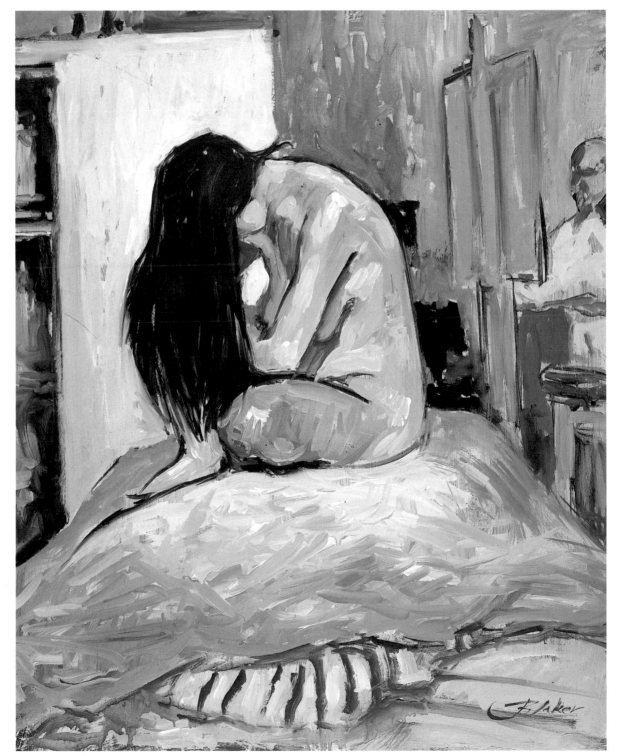

Index

Figures in *italics* refer to illustrations

artist's turpentine 12

Barbizon School 9
Blaker, Michael
 Artist and Model 79
 Artist Painting Sunflowers, The 38
 Autumnal Fruits and Old Man's Beard 32
 Bath, The 79
 Beach Umbrellas 49
 Birch Tree at Fittleworth 27
 Bride, The 57
 Broadstairs Beach with Punch and Judy 48
 Catriona and Hero in the Garden at Rochester 16
 Catriona at the End of the Garden 39
 Catriona in the Garden 41
 Catriona Relaxing in the Garden 38
 Catriona under a Tree 21
 Chess Game, The 70
 Chrysanthemums and Delphiniums in a Vase 4
 Chrysanthemums in a Green Vase 34
 Country Lane, October Afternoon, A 15
 Dahlias 34
 Dahlias in a Vase 33
 Dahlias on a Table 9
 Dead Badger 1 44
 Dead Badger 2 45
 Denis 76
 Denis Playing Banjo 75
 Departing Storm at Evening 55
 Donkey in Stable 46
 Downs and the Weald, The 22
 Dresser, The 59
 Fisherman on the Beach 51
 Flowers and Garden Furniture 34
 Flowers in a Garden 36
 Flowers: Study in Blue 10
 Garden Furniture and Flowers 38
 Girl in a Headscarf 66
 Girl in Blue 72
 Girl in Boots 64
 Girl with Blonde Hair 60
 Girl with Cat 56
 Girl with White Socks 65
 Gurnards and Sprats 44
 Helen and Madonna Lilies 39
 Helen under a Tree 41
 Hero and Chrysanthemums 47
 Inflated Giraffe, The 49
 Jean in Red 72
 Jenny Nude 4
 Jenny Nude with Cat 77
 John Doreys 44

 Late Summer Afternoon, Hove 31
 Life Group 23
 Life Painting Group 77
 Mackerels 44
 Mantelpiece, The 59
 Man with a Cigarette 9
 Man with a Pipe 18
 Meadowsweet Cabin with Sunflowers 17
 Nicki in an Overcoat 64
 Night and Rain 55
 Old Power Station and Hove from Lancing Beach, The 4
 Old Power Station from the Beach, The 18
 Old Steamer 51
 Old Tollbridge, Shoreham, The 14
 Orchard at Woodlands, Wiltshire, The 11
 Overgrown Avenue, The 27
 Palace Pier, Brighton, The 18
 Pheasants 45
 Piano, At the 59
 Piano, At the 75
 Rock and Sea 30
 Rod Painting 76
 Rod with Sousaphone 72
 Rough Sea 55
 Seated Nude in a Life Session 79
 Seated Nude in Life Group Session 9
 Self-Portrait in a Window at Night 68
 Self-Portrait in the Park with Dogs 68
 September Afternoon in the Mall, London 13
 Snow in Rose Street 55
 Spats Drawing 66
 Spats Thomson 70
 Story at Bedtime 57
 Studies of Heads 60
 Study of a Dead Bird 44
 Study of a Dead Fox 25
 Study of a Nude with Red Hair 79
 Study of Hands 56
 Study of Head 57
 Summer Beach Scene 51
 Summer Evening 52
 Summer Evening with Lancing College Chapel 52
 Sunlight on Water 28
 Sunset on the Medway 52
 Sweep in his Basket 47
 Tea in the Garden 62
 Trees at Berwick, Sussex, with the South Downs 13
 Tree Study, Morning 18
 Trumpet Player, The 72
 Turkish Girl 72
 Val 1 63
 Val 2 63
 View of Poynings and the Sussex Weald 29
 View of the Downs from behind the Church at Berwick, Sussex 12
 Washing on a Line 15
Botticelli 59
Bratby, John 26
Bruges, Belgium 60
brushes 14-15

Campin 60
canvas 20-21, *20*
case (for carrying panels) 24
Cézanne 72
Claude glass, a 30
cleaning 24
colors 10-14, 16
 mixing 12
 thinning 12
Couture, Thomas 77
 Romans of the Decadence 77

egg tempera 7

Fittleworth, Sussex 18

Gauguin 9
glazing 8, 59, 66

Hals, Frans 10
Holbein 61

Impressionists 9
Ingres, Jean-Auguste 9
 Grande Baigneuse 77
 Source, La 76, 77

John, Augustus 30

Landseer 46
Lautrec, Toulouse 43
linseed oil 7
Lippi, Filippino 59
Louvre, Paris 6

Manet, Edouard 43
 Bon Bock, Le 69, 69
 Olympia 77
Matisse 79
medium 12, 13
Memling 60
da Messina, Antonello 7
Michelangelo 59
miniatures 60
Modigliani 77
Musée d'Orsay 6, 77

National Gallery, London 6
National Gallery of Art, Washington 6
Nicholson, Sir William 43

panel paintings 60-66
pantograph 61
Perugino 8
photography 46, 56
Picasso, Pablo 15
pochades 17-18
poppy oil 7
Post-Impressionists 9
premier coup 29, 44

Raphael 8, 59
Rembrandt 8
Reynolds, Sir Joshua 9, 10

Sargent, John Singer
 Claude Monet Painting at the Edge of a Wood 7
scumbling 22-23
Sisley, Alfred
 Canal St Martin, Paris, The 7
 Small Meadows in Spring 11
size, rabbit-skin 20

techniques, preliminary 22-25
Titian 9

toning 22-23
trompe l'oeil 59

Uffizi Gallery, Florence 69
undercoat 22-23

Van Eyck 60
Van Gogh 9, 26, 66
varnishing 24-25

Whistler 19

Acknowledgments

The publisher would like to thank David Eldred, designer, Jessica Hodge, editor, Veronica Price, production manager and Helen Dawson, indexer. We should also like to thank the following institutions for the loan of photographic material. All illustrations are by the author unless otherwise stated.

Musée d'Orsay, Paris: pages 7, 76 (below right)
Philadelphia Museum of Art: page 69, (Mr and Mrs Carroll S Tyson Collection)
Tate Gallery, London: pages 6, 11 (bottom)